Augusta

IN VINTAGE POSTCARDS

Augusta
IN VINTAGE POSTCARDS

Joseph M. Lee, III

ARCADIA

Copyright © 1997 by Joseph M. Lee III
ISBN 0-7524-0942-5

First published 1997
Reprinted 2004

Published by Arcadia Publishing,
Charleston, SC; Chicago, IL; Portsmouth NH; San Francisco, CA

Printed in Great Britain

Library of Congress Catalog Card Number applied for

For all general information contact Arcadia Publishing at:
Telephone 843-853-2070
Fax 843-853-0044
E-mail sales@arcadiapublishing.com
For customer service and orders:
Toll-Free 1-888-313-2665

Visit us on the internet at http://www.arcadiapublishing.com

Contents

Acknowledgments

Everyone that I have talked to regarding this project has offered support and encouragement. Bill Baab and Rusty Bailie have been especially helpful. Erick Montgomery and his staff at Historic Augusta were very cooperative when I asked about research in their files. The reference staff at the Augusta State University Library were quite understanding when I frequently laid out fifteen years of city directories on the table in the Special Collections room. Friends and fellow collectors in the Georgia Postcard Club have helped me find Augusta postcards for almost twenty years. Many postcard dealers have made a special effort to search for good Augusta cards. I appreciate their efforts. My family has been especially supportive and patient over the past several months. My sisters in Augusta, Mary Lee and Nancy Lee Casto, have accommodated my every need. Virginia, my wife of thirty-four years, has been the most patient and supportive of all. Without her help and understanding, this book would have never been completed.

Introduction

This picture history is a snapshot view of Augusta as it was in the first two decades of the twentieth century. The face of Augusta has been dramatically altered since that time. As Augusta prepares to move into the twenty-first century and into a new millennium, this book can serve as a benchmark or point of reference from which we may measure how much it has changed.

Over the past two hundred years, Augusta has survived floods, fires, earthquakes, and a civil war. In the first two decades of the twentieth century, Augustans had to deal with two major catastrophes: the August 26–27, 1908 flood, which was Augusta's most destructive flood, and the March 22, 1916 fire, which burned over seven hundred structures and left over three thousand people homeless. These were all just notable events compared to the self destruction of the 1950s, 1960s, and 1970s to create parking lots, office buildings, apartment buildings, libraries, bus stations, motels, shopping centers, medical complexes, roads, and bridges—all in the name of progress. The legacy of our heritage left to us by our forebearers appeared to have been forgotten or ignored. Fortunately, it has recently been rediscovered, and our history is now being promoted as one of our greatest assets.

In the first two decades of the twentieth century, postcard collecting became a national fad. The picture postcard, or view card, was the most popular type of card. Every aspect of Augusta's history was documented during this period. Street scenes, homes, businesses, civic buildings, transportation in all forms, floods, fires, fire engines, bridges, schools, medical facilities, military encampments, orphanages, parks, and more were captured by the photographer to provide us with an unparalleled visual record of Augusta. Many postcard views are the only visual record we have on a subject. Messages found on many cards embellish the picture, as the writer expresses his or her views of the surrounding world. These view cards, supplemented by a few contemporary amateur photographs and a few billhead views of businesses, comprise this picture history of Augusta's first two decades of the twentieth century.

During this same period, Augusta's civic and business leaders were engaged in a heavy promotional campaign to build up Augusta as a commercial center. Thomas Loyless, the editor and publisher of the *Augusta Chronicle* from 1903 to 1919, was an avid civic promoter who used the newspaper to promote Augusta. The Augusta Chamber of Commerce was organized in 1905, largely due to prodding by Loyless and the *Chronicle*. His efforts were also behind the construction of the ten-story Chronicle Building, now known as the Marion Building (Bell and Crabbe, *The Augusta Chronicle* 1785–1960, pp. 150–151). Local lobbyist promoted Augusta as a splendid site for a World War I training camp, and as a result, Camp Hanock was established on the west side of the Hill. The literature published by the various organizations involved in the promotional campaigns provides outstanding documentation for the view cards. The campaign literature is reflected in the captions on a few of the cards.

The photographs used to print the postcards were taken by various photographers. Most are undocumented. Some postcard firms had salaried photographers that would travel to a town on assignment to take pictures. Many of the photos were taken by local photographers. There were photo supply stores that had negatives on file for anyone to use. There are a number of Augusta views issued by different printers that are from the same original negative on file at some photo supply store. Anyone could take a photo of a scene or business and send it to Germany to have it printed. The highest quality cards were printed in Germany before 1914, when WW I began. One Augusta photographer that is documented on some of the prettiest Augusta cards made is Juan Montell. Montell's business was continued by his nephew Frank Christian Sr., whose son, Frank Christian Jr., is the current owner of the Frank Christian Studio. There are a number of cards with a local person or business listed as the publisher: Silvers 5 & 10 Cent Store, Steve's Place, Albion News Co., Murphy & Farrar, John F. Dugas (African-American subjects), Miss W.D. Thomas, Williams New Book Store, Murphy Stationery Co., and Prontaut Jewelers, among others. All the postcards, photographs, and billheads used in the book are from the author's collection.

G. Lloyd Preacher was an architect in Augusta during the postcard tour period. He designed so many buildings that he has been credited with creating modern Augusta. When it is known that a building pictured in a postcard was designed by Preacher, it is so noted.

Here is one note about the direction the streets run in Augusta with regard to the compass. Broad Street actually runs from southeast to northwest. For ease of explanation, the postcard publishers assumed that Broad Street ran directly from east to west. All scenes looking towards East Boundary are described as looking east. All scenes looking towards Fifteenth Street are described as looking west. This continues for all streets running parallel to Broad Street. All streets crossing Broad Street are assumed to be running north and south. The same assumption is made for all directions given in this book.

"Queen City of the South Atlantic States," "Queen City of the Savannah Valley," "The Coming City of the South," "The Lowell of the South," and "Garden City of the South" were all labels applied to Augusta by its promoters during this era. I hope this book will provide you with a lasting visual record of what Augusta was like during those times.

One
Broad Street

Broad Street was the heart and soul of Augusta, as well as the center of business and commerce. In the early 1900s, Augustans lived and worked all along its 2-mile length from East Boundary to Fifteenth Street. Our tour will begin at the eastern end of Broad Street.

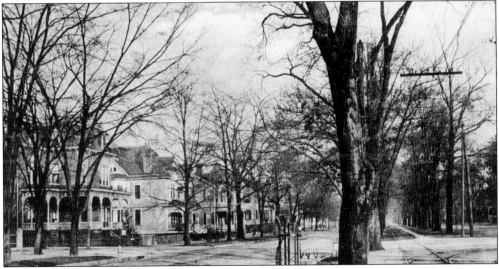

Lower Broad Street, looking east from Lincoln (Third) Street, c. 1905. The corner house at 267 was the home of attorney Irvin Alexander, who was also secretary of the Alexander Drug Company. The second house at 261 was occupied by Hugh H. Alexander, who was associated with Alexander, Johnson and Steiner, dealers in real estate, rentals, loans, and insurance. These homes burned in the 1916 fire.

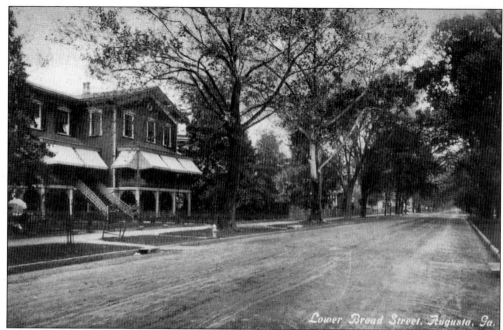

Lower Broad Street, *c.* 1908. This shows the home of James F. McGowen, cotton merchant and president and general manager of the Georgia Compress Co. This home burned in the 1916 fire, and the Broadway Apartments were built on the site. The card message reads: "We made no mistake in our selection. The charm of this place is upon us. The time going too rapidly. All the spring flowers in blossom while the trees have their feathery green dress. I love it and hate to go home."

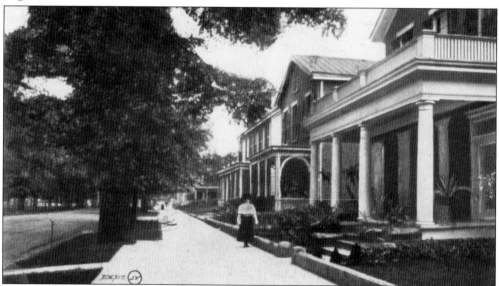

The south side of Broad Street, looking east, *c.* 1906. The nearest house was number 338, the residence of John H. Davison, of Davison and Fargo, cotton factors. The second house at 334 was the residence of Mrs. Martha E. Meyer, the widow of Charles H.R. Meyer. The third house at 332–330 was a duplex. It was occupied by Mr. Frank T. Graham and Mrs. Louise Dodd, the widow of Charles E. Dodd. All the houses burned in the 1916 fire.

10

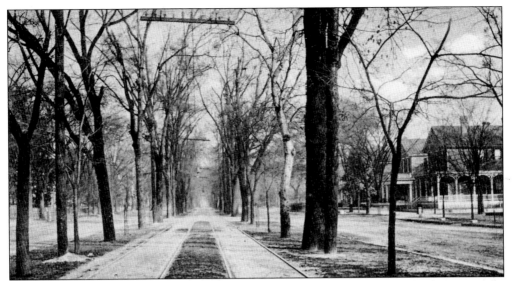

Lower Broad Street looking east from Elbert (Fourth) Street, *c.* 1905. The house on the southeast corner at Elbert Street was number 342, the residence of Mrs. Alice H. Garrett, the widow of William A. Garrett. This home and the house next door at 338, which can be seen on the previous card, both burned in the 1916 fire. The postcard message reads: "This is the <u>lower end</u> of the business street of Augusta private residences and electric cars running through the trees."

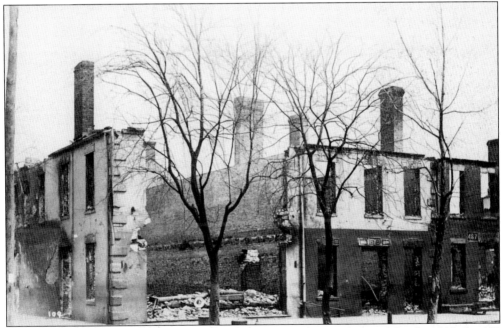

Northeast corner of Broad Street and Centre (Fifth) Street, after the 1916 fire. In 1916, the 400 block of Broad Street was residential up to the last six to eight lots before Centre Street, which were taken up with stores. Estes E. Carroll, a grocer, occupied the corner store at 473. This card message from February 11, 1917, reads: "Augusta is a very large place, last March they had a terrible fire over 12 blocks on one side. They have not cleared away the debris."

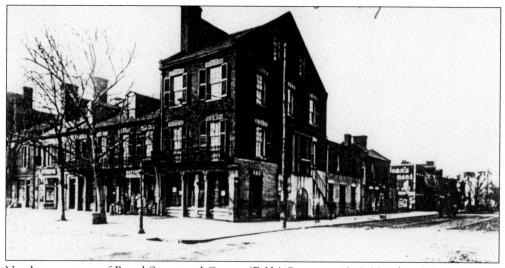

Northwest corner of Broad Street and Centre (Fifth) Street, *c.* 1912. Number 501, the corner structure, is thought to have been built by Ferdinand Phinizy *c.* 1818. In 1912, the structure was the residence of Frank B. Carr, who operated a saloon on the ground floor. All the buildings in the photograph burned in the 1916 fire. (Photograph courtesy of the late F. Phinizy Calhoun Jr., M.D., F.A.C.S.)

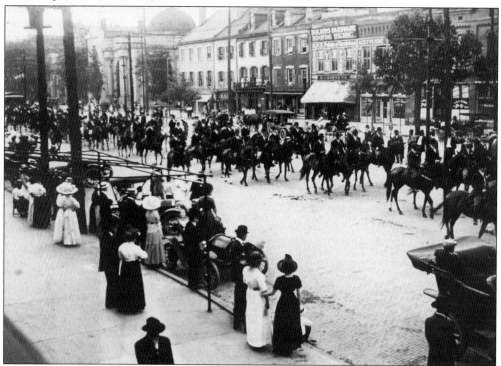

The Confederate Memorial Day parade, 600 block of Broad Street, on the way to the City Cemetery (Magnolia Cemetery) for speeches and flower-laying ceremonies at the veterans' graves, *c.* 1912. The R.J. Horne Hardware Store at 643 Broad Street (Builders Hardware sign) opened in 1910 or 1911. The 1916 fire skipped the 600 block of Broad, earning it the name the "Miracle Block." The building was restored by the Georgia Railroad Bank in 1983.

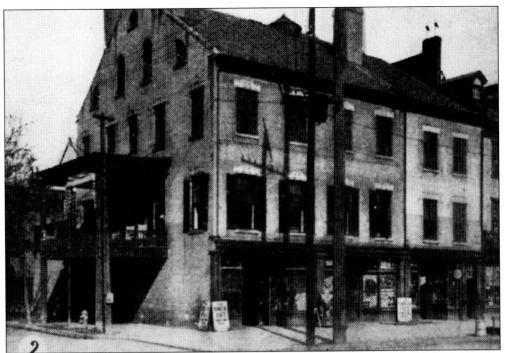

Augusta Lodge, B.P.O. Elks, No. 205, on the second and third floors at 659 Broad Street on the northeast corner of McIntosh (Seventh) Street in 1908. The club contained all the requisites of club life, including a reading room, an up-to-date restaurant, a sitting room, a billiard room, and a club buffet. Its members were prominent citizens involved in all matters of public enterprise and charitable works. The site is now occupied by the First Union Bank building.

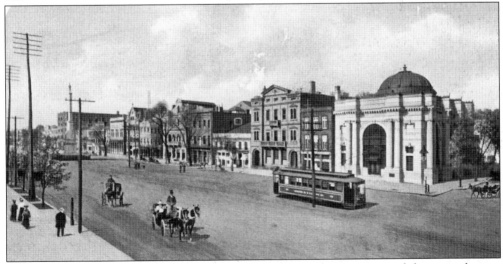

The north side of the 700 block of Broad Street. The area has experienced dramatic changes caused by fire and progress since 1903, when this photo was made. The Georgia Railroad Bank at 701 Broad Street, on the corner of McIntosh (Seventh) Street; the office building next door at 705; the 707–709 building containing the National Bank of Augusta and the Planters Loan and Savings Bank; and the fourth building at 711–713 containing retail stores and offices would all soon see changes.

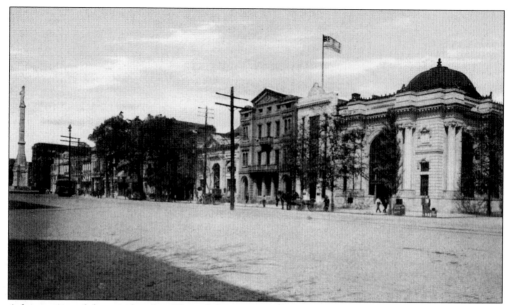

A later view of the north side of Broad Street's 700 block. By 1908, Planters Loan and Savings Bank had replaced the old office building at 705 Broad Street with a new building, and the Irish-American Bank had replaced the retail store building at 711–713 with a new building and a new address of 715. The National Bank of Augusta remained at number 709. This corner has anchored the banking business in Augusta for many years.

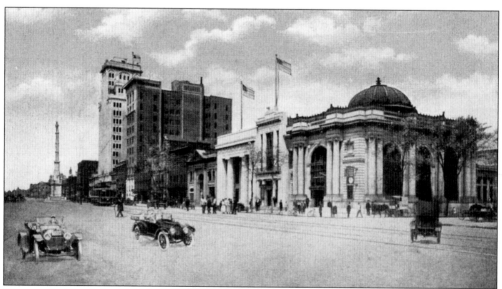

The north side of the 700 block of Broad Street, just before the March 1916 fire. By this date, the Empire Life Insurance Company building and the Chronicle Office Building were constructed. The Citizens and Southern Bank building has replaced the old National Bank of Augusta building at 709.

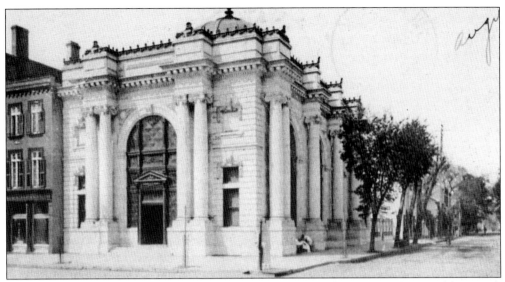

The Georgia Railroad Bank, at 701 Broad Street at the northwest corner of McIntosh (Seventh) Street, 1903. This new structure opened in 1902, replacing the original 1836 building. The bank moved to a new seventeen-story building at 699 Broad Street in 1967. The card message reads: "This is a good picture of a bank. To my sister from her brother who is alone in Augusta."

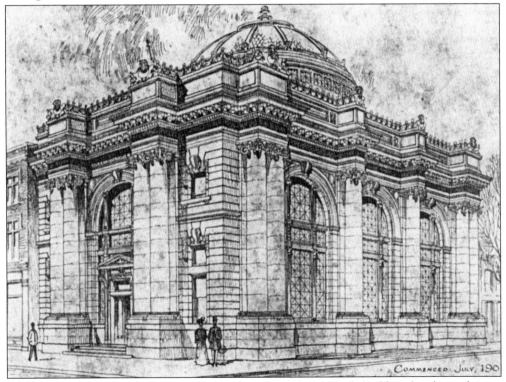

Rarely seen architectural drawing of the Georgia Railroad Bank building by the architects Mowbray and Uffinger of New York. One can compare how faithful the construction was to the proposed plans.

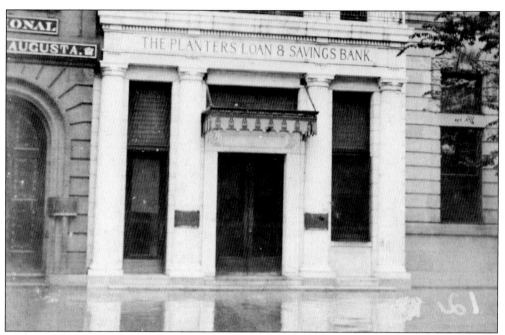

The Planters Loan and Savings Bank building at 705 Broad Street. The bank was brand new when the August 1908 flood struck Augusta. The bank paid 4% on deposits, which could be made by mail. The Planters merged with the Citizens and Southern Bank in 1921. The card message reads: "Dear Bill, Am in the land of cotton and pretty women. Can gross about 30 gals per acre. Yours, Andy."

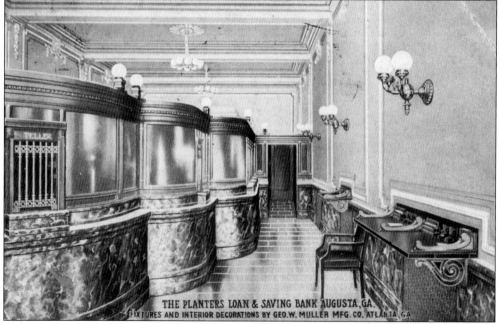

Interior of the Planters Loan and Savings Bank. The Geo. W. Muller Manufacturing Company in Atlanta, Georgia, featured this view on an advertising card sent to the Bank of LeCompte, in LeCompte, Louisiana, in January 1909.

16

The Citizens and Southern Bank at 709 Broad Street. The bank opened on July 1, 1912. Mills Lane Sr. of the Citizens and Southern Bank in Savannah bought the National Bank of Augusta, demolished the building, and erected a new building on the site. The bank subsequently expanded its facade to enclose the Planters building and finally, the Georgia Railroad building in 1970. The site is now occupied by the NationsBank building.

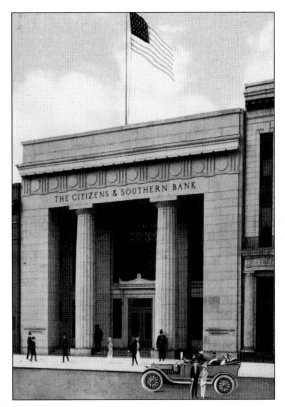

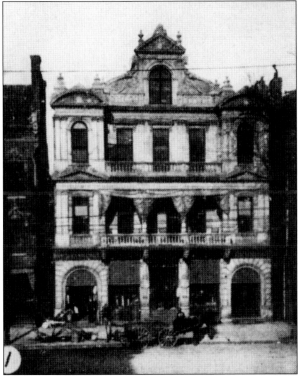

The Commercial Club at 727 Broad Street. The club, a membership club for the businessmen of Augusta and their visitors, was featured in this photograph in the Chamber of Commerce's 1908 Yearbook. The club featured billiards, cards, a reading and lounging room, a dining room that could serve one hundred guests, and private dining rooms. Day and Tannahill Hardware Supplies occupied the ground floor. The building burned in the 1916 fire, and the Augusta News Building at 725 Broad Street occupies the site today.

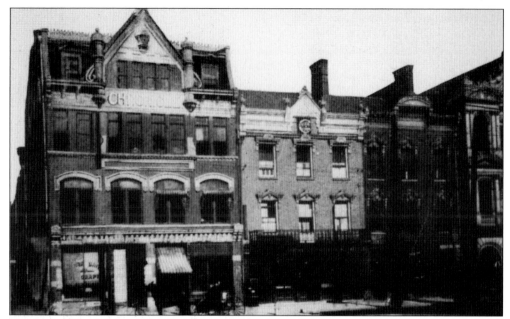

Newspaper Row, the middle of the 700 Block of Broad Street on the north side, 1908. The *Augusta Chronicle* had moved into its new building at number 739 in August 1892. The Central of Georgia Railroad offices were in the adjacent building at 735. The *Augusta Herald* occupied the next building at 731. All the buildings burned in the 1916 fire. The Chronicle Building location is now the site of the Marion Building at 739 Broad Street.

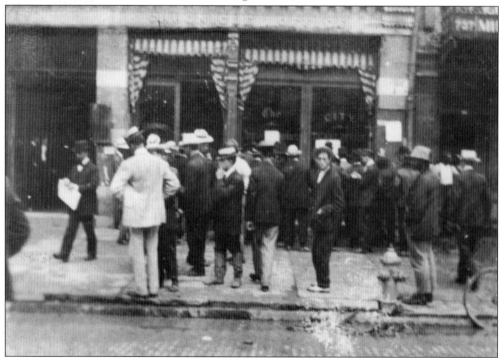

739 Broad Street. Augusta citizens anxious for the latest news gather in front of the Chronicle Building to check the bulletin board after the August 1908 flood.

Chamber of Commerce headquarters building at 747 Broad Street in 1908. Western Union Alley (renamed Tubman Alley after the 1916 fire) separated Commerce Headquarters from the old Chronicle Building. Thomas W. Loyless, editor of *The Augusta Chronicle*, was the president when the Chamber published its first yearbook in 1908, a yearbook published by the Chronicle Press, of course. The building burned in the 1916 fire. The Imperial Theater is located on the site today.

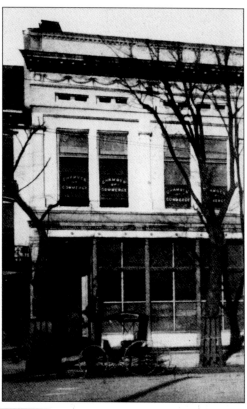

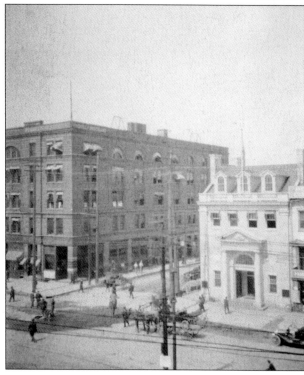

The Union Savings Bank, the last building on the north side of the 700 block of Broad Street, shown on the right in this 1912 photograph, at the northeast corner of Jackson (Eighth) Street. The building at number 769 had been the home of the Young Men's Library Association for twenty years when it was purchased by the bank in 1908 and remodeled for their purposes.

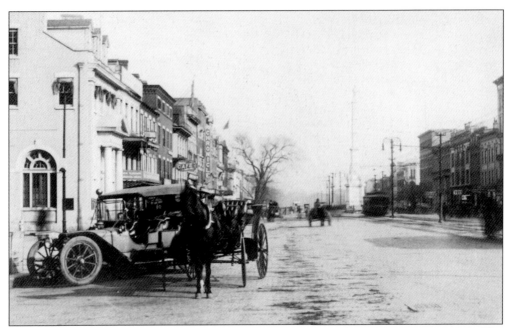

Ground-level view of Broad Street looking east from Jackson (Eighth) Street, c. 1912. The Union Savings Bank building at 769 Broad Street is on the left. The cafe sign advertises the Royal Cafe for Ladies & Gents at 757 Broad Street. Pollution from transportation vehicles was nothing new to the folks in 1912.

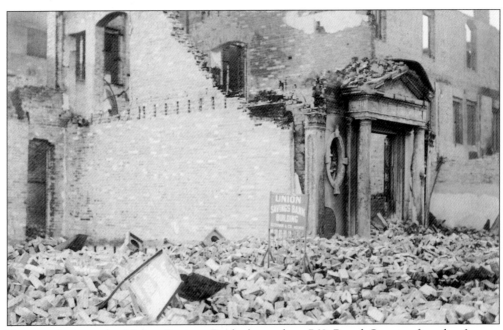

Damage done to the Union Savings Bank, located at 769 Broad Street, after the fire on March 22–23, 1916.

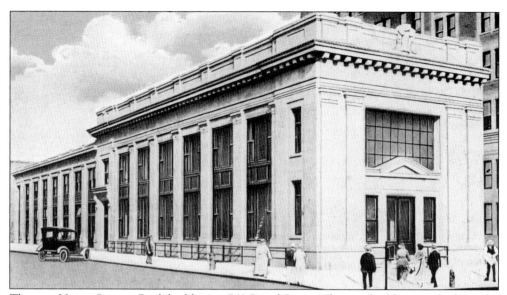

The new Union Savings Bank building at 769 Broad Street. The new building was built on the site of the old building. The Union Savings Bank office building is shown at the rear at 126–144 Jackson (Eighth) Street. Although the bank has long been closed, the building survives but is unoccupied at present.

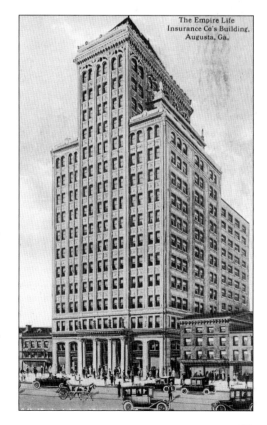

Empire Life Insurance Company Building. Construction began on this structure in late 1913. Financial problems delayed completion of the building, and it was burned out in the 1916 fire. A renovated structure opened in July 1917 as the Lamar Building, but it was renamed the Southern Finance Building in 1924. Mr. I.A. Schmidt was the first superintendent. Mr. Schmidt came to Augusta in 1917 to help with the renovation. Mr. Schmidt and his wife lived in a thirteenth-floor apartment, and he was available for service day or night. The building is currently in operation as the Lamar Building.

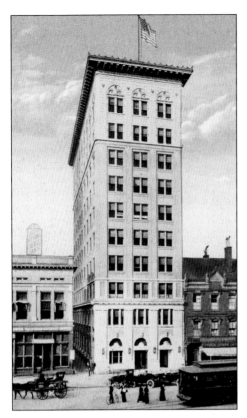

The Marion Building, 739 Broad Street. The structure was built in 1914 as the Chronicle Office Building. G. Lloyd Preacher was the architect. The building burned fifteen months later in the March 1916 fire, and the *Chronicle* moved to 737–739 Ellis Street. The Chronicle Office Building was renovated by new owners and renamed the Marion Building. The building is vacant at the present time.

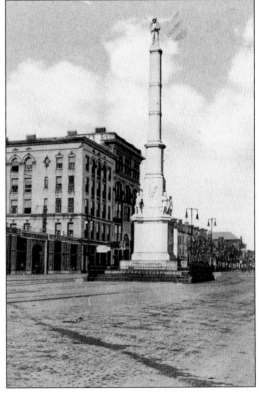

The Confederate Monument, c. 1912 postcard, in the middle of the 700 block of Broad Street. The monument was dedicated on October 31, 1878, before an estimated crowd of ten thousand, and it is a popular subject for postcards. The author has twenty-six cards with views of the monument, and it is seen in many Broad Street views. This card message reads: "We took an electric car to Augusta, Ga. yesterday (from Aiken) then rode all around the city. It is a nice city with lovely homes. Our car stopped right beside this monument."

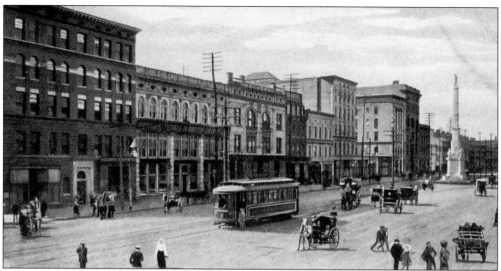

South side of the 700 block of Broad Street looking west, c. 1903. The five-story Leonard Building on the southwest corner at McIntosh (Seventh) Street was brand new at the time. The three-story King Building, located to the right of Leonard Building, contained three stores on the ground floor. The Montgomery Building was next on the right, and then Dorr's, at number 724 Broad. All the buildings survive today. The Allied Bank is now located in the Leonard Building.

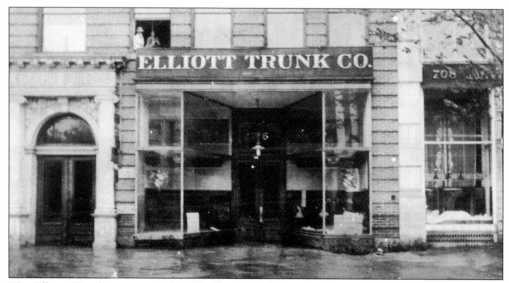

The Elliott Trunk Company, 706 Broad Street, during the August 1908 flood. The company was located on the ground floor of the Leonard Building. A.J. Renkl, Jeweler, was located at 708 in the King Building. At a later time, 708 was the entrance to the Miller Theater.

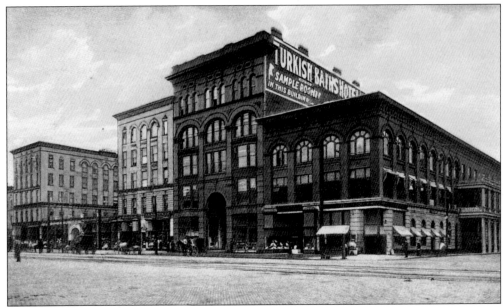

The south side of the 700 block of Broad Street, looking east from Jackson (Eighth) Street, c. 1907. The Miller-Walker Building (on the right) was on the southeast corner of Jackson and Broad. Its main entrance was on Jackson Street. The Savoy, novelties and specialties, occupied the corner store, and T.G. Howard was its proprietor. The Harrison Building was next door. The Albion Hotel is the third building (far left). All had commercial space fronting the street on the ground floor, and all burned November 26, 1921.

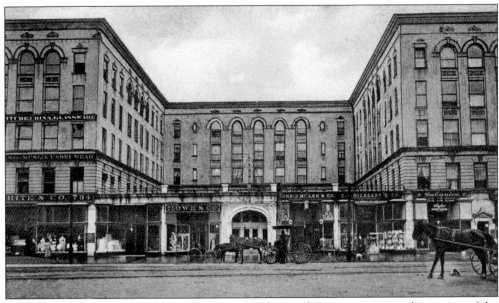

The Albion Hotel, 738 Broad Street, 1906. J.B. White and Company occupied a portion of the building on the left, which survived the 1921 fire and was operated at that location for many years. The card message reads: "In the background is White's the swell dry goods shop here. The shops are very dark and dingy—not very attractive."

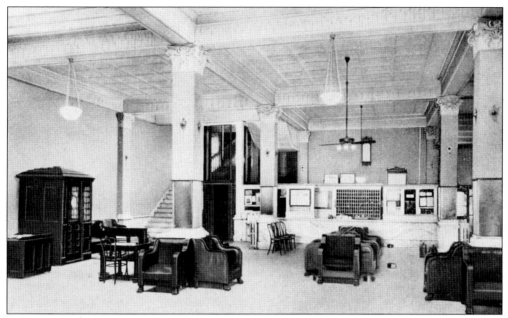

The lobby of the Albion Hotel. The Albion replaced the Arlington Hotel, which burned December 11, 1899. The Albion was advertised as the "Leading Hotel in Augusta, Rates $2.50—$4.00, Headquarters for Commercial Men, Large Sample Rooms."

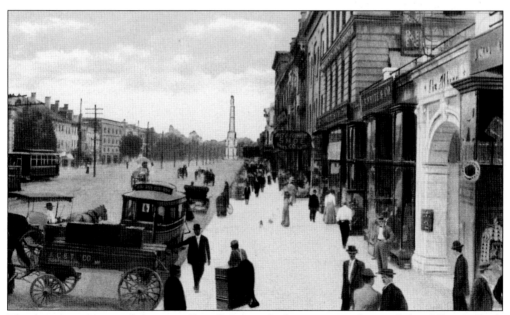

The business center of Augusta, Broad Street, looking east in front of the Albion Hotel, c. 1909. Rice and O'Conner Shoe Company, shoes and hats, operated at 730 Broad Street for several years in the early 1900s. The wagon being loaded with luggage was from the Augusta Cab and Transfer Company at Union Station, who advertised "Baggage checked from residential and hotels to all parts of the U.S."

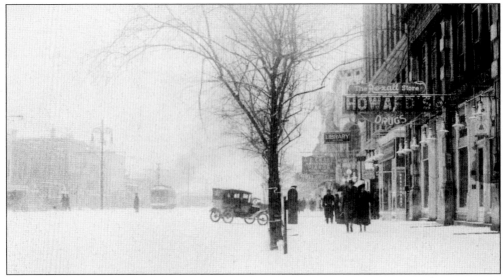

The 700 block of Broad Street, December 31, 1917, after a heavy snowfall. Howard's Drug Store at number 710 was in the middle store of the King Building. The Young Men's Library Association was located on the fifth floor of the Leonard Building. L.A. Russell Piano Company and Walton's Dairy Lunch were located in the 600 block.

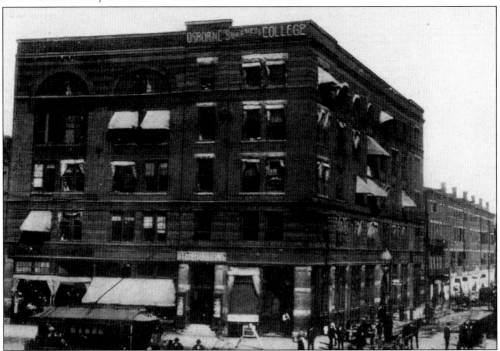

The Dyer Building, located on the northwest corner of Broad Street and Jackson (Eighth) Street. The building was named for Col. Daniel Burns Dyer, president of the Augusta Railway Company. Col. Dyer came to Augusta from Kansas City to build an electric car line to replace the mule-drawn cars. The car line began operating in June 1890. The Dyer Building was the first office building in Augusta wired for electricity. The Warren Block buildings on Jackson Street are visible in the background. The March 22, 1916 fire started in the Dyer Building.

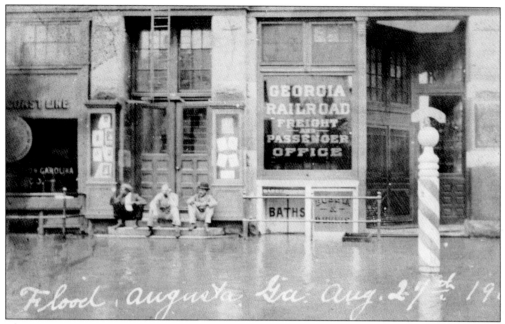

The entrance to the Dyer Building during the August 1908 flood. The card message reads: "937 Broad St. We are well. Just had a lovely turkey dinner. Address me at the above address. That is where we get our meals."

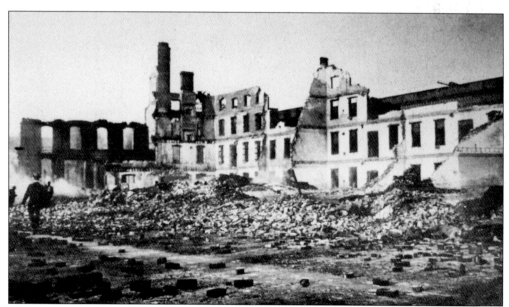

The ruins of the Warren Block on Jackson Street and the "fireproof" Dyer Building, Richards Stationery Store, and the United States Cafe on Broad Street after the 1916 fire. This was the western end of the fire boundaries. The next building on Broad Street was the Merchants Bank, which suffered water and smoke damage but survived the fire.

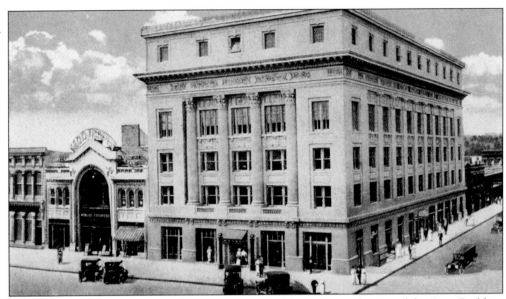

The Masonic Building. The building was constructed in 1918, on the site of the Dyer Building on the northwest corner of Broad Street and Jackson Street. The New Modjeska Theater was built in 1916 on the site of Richards Stationery Store and the United States Cafe. G. Lloyd Preacher was the architect for both buildings. The Masonic Building was demolished in 1967 and replaced by the eleven-story First National Bank and Trust Company building, which is now the SunTrust Bank building.

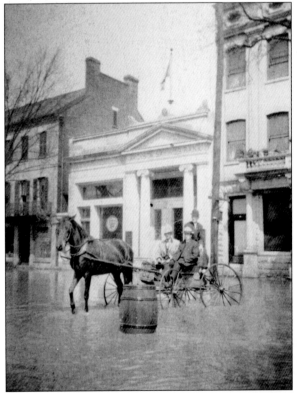

The Augusta Savings Bank at 827 Broad Street. Constructed in 1909, the bank is shown here during the March 1912 flood. The man in the buggy on the left front is Lieutenant George J. Heckle of the Augusta Police Force (in civilian clothes). The man on the right front is his son-in-law, Orlin K. Fletcher, D.D.S. (the great-grandfather and grandfather of the author). The man in the rear is Mr. Grealish.

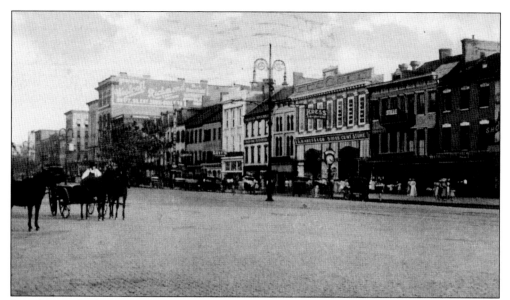

Broad Street looking east, c. 1913. S.H. Kress had just moved to 832–838 Broad Street from 958 Broad Street. The card message reads: "Do you remember this place or didn't you get down here while you were in Aiken. We went over on the trolley one day when I was not working to do some shopping. A great many things can be bought cheaper over in Augusta than in Aiken."

I.C. Levy's Son and Company, 1906. "Call for me at I.C. Levy's Clothing House," wrote Mr. Ernest B. Satcher on this card mailed on October 29, 1906. The company sold clothing for men and boys, hats, furnishings, and leather bags at 858 Broad Street.

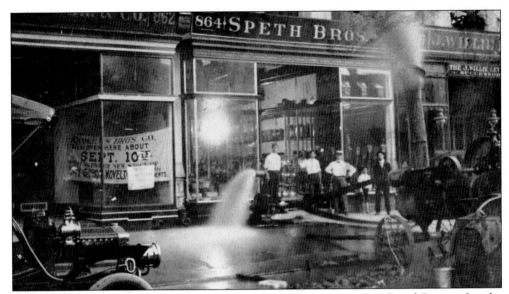

Water being pumped from Speth Bros. stove and hardware store at 864 Broad Street, after the August 1908 flood. Speth had moved into the building from 840 Broad Street just before the flood hit.

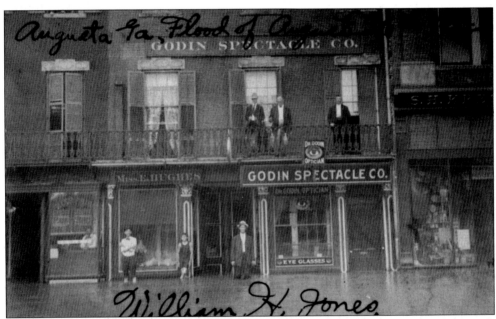

Mislabeled October 6, 1929 *Augusta Herald* photograph. The paper stated that the photograph on page five was of the flood of 1888. The photograph was actually taken during the flood of August 1908 at 956 Broad Street. The caption identified the people on the upper piazza, from left to right, as R.W. Roper, Jules Godin (founder of Godin Spectacle Co.), and Dr. Henry J. Godin, his son. Miss Ellie Hughes's millinery store is on the left, and S.H. Kress is on the right at 958.

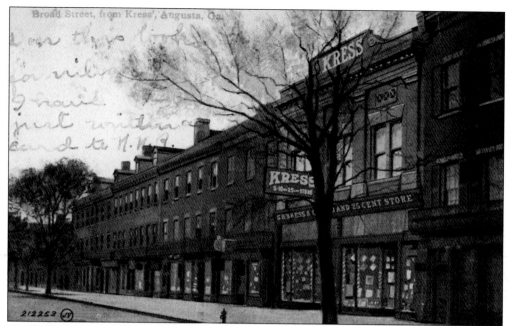

The S.H. Kress store, located at 958 Broad Street from 1908 to 1912. In this postcard, Godin Spectacle Company is on the left at 956 Broad. S.H. Kress opened in Augusta in 1898. They were located in the Montgomery Building from 1898 to 1902, at 854 Broad from 1903 to 1907, and at 958 Broad from 1908 to 1912. They moved to 832–838 Broad in 1913 and remained there for many years.

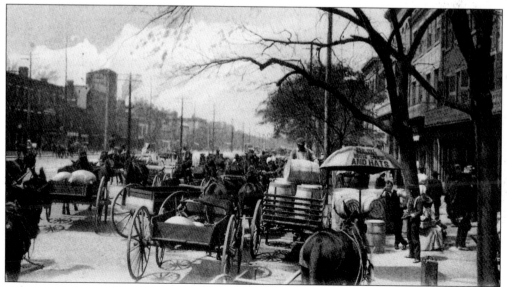

A busy morning on Broad Street, c. 1904. The umbrella advertises "Red Hot Bargains, Boots, Shoes and Hats" for the Great Eastern Shoe Co. at 915 Broad. The kegs are probably from proprietor Frank Rouse's Murry Hill Distillery, at 923. The barely visible sign on the next building is J.E. Tarver Hardware at 927. The still-existing four-story building at 972 Broad can be seen on the left.

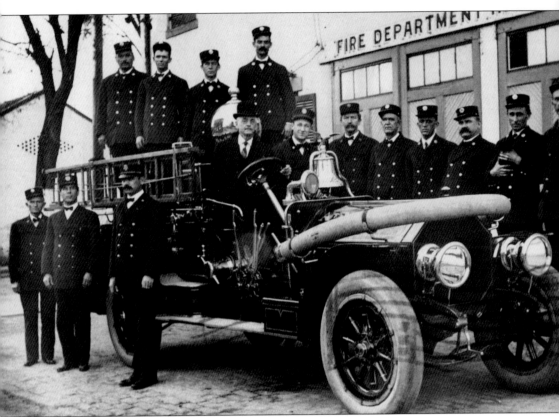

Mayor William M. Dunbar in the driver's seat of Augusta's brand new Webb Automatic Fire Engine and Hose Wagon combined, 1909. Chief Frank G. Reynolds is standing beside the machine, just to the left of the mayor. Purchased in October 1909, the auto-engine was built on a Thomas Flyer Chassis, had a 90-horsepower, six-cylinder engine, with a top speed of 60 miles per hour, and a pumping capacity of 900 gallons per minute. It also carried 1,000 feet of 2.5-inch fabric hose, one 20-foot extension ladder, one 12-foot roof ladder, two axes, two Babcock fire extinguishers, and a crew of eight. The men and the engine are pictured in front of Fire Department Headquarters (Chemical No. 1) on Jones Street at Macartan Street (*Year Book 1909*). The building survives today because Mr. Alonzo P. Boardman Sr. purchased the abandoned structure in 1936 and had it renovated.

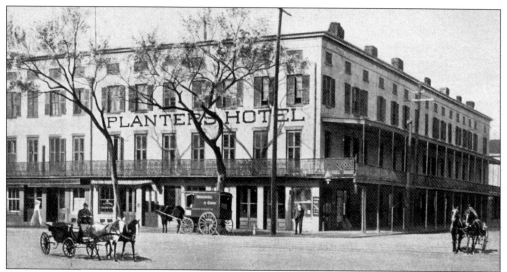

The Planters Hotel at 945 Broad on the northwest corner at Macartan Street, *c.* 1903. The sign on the wagon advertises "Crackers and Candy." This was the second Planters Hotel. The first was located on the site of the old fire department headquarters shown in the previous view. The building burned in 1836. The Marquis de LaFayette was a guest at the old Planters in 1825. Jefferson Davis, Robert E. Lee, Ulysses S. Grant, and Phil Sheridan were famous guests at the Planters during the 1870s.

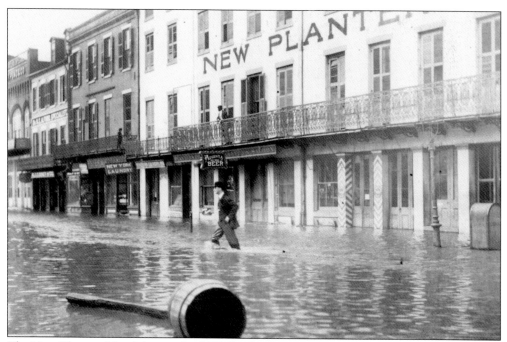

The New Planters Hotel during the 1912 flood. The New Planters was a remodeled version of the old Planters. The most obvious change, besides the name, was the removal of the balconies along Macartan Street. The last three buildings exist today as part of LaFayette Center, which was developed by Bankers First in the mid-1980s.

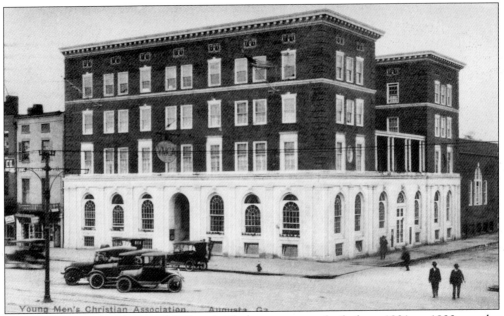

The new YMCA building at 945 Broad. The structure was built from 1921 to 1923, on the site of the Planters Hotel. The YMCA closed the building in 1983. It is now part of LaFayette Center complex. The card message reads: "We are going through this place and it is some dirty place. "

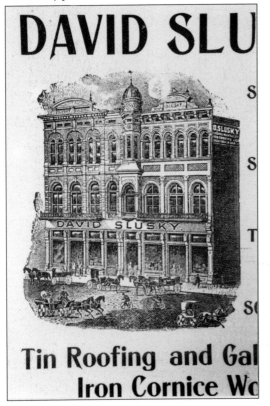

A 1904 ad which featured David Slusky, located at 1009 Broad, dealer in stoves, ranges, mantels, tiling grates, tin roofing, galvanized iron, cornice and sheet metal work, skylights, etc. The business was established in 1886 by David Slusky, one of Augusta's leading citizens for many years, who was known to locals as Uncle Dave. His son, Moses Slusky, entered the business about 1920. It became Slusky Builders' Supplies Inc. in the mid-1940s. The building, remodeled in 1932, still stands.

34

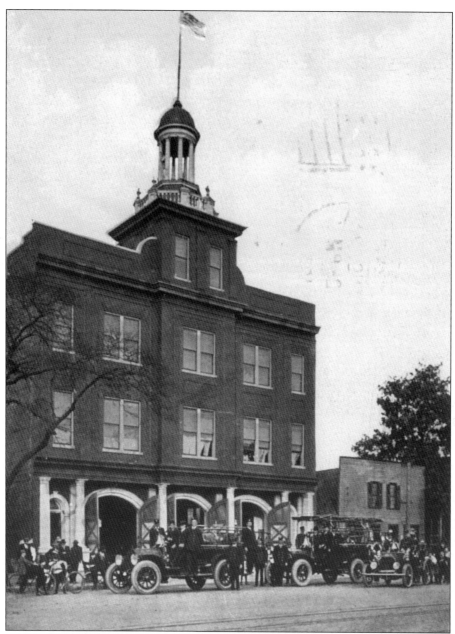

Augusta Fire Department headquarters building and new automobile fire engines at 1253 Broad Street, c. 1910. The building was constructed from 1909 to 1910 by J.H. McKenzie's Sons and was designed by architect G. Lloyd Preacher. The new building was opened May 10, 1910, at 9 pm, at a ceremony attended by the mayor, Fire Committee, members of Augusta City Council, city officials, and representatives of the different fire insurance companies. The equipment was located on the ground floor. The chief's office, sleeping rooms for the men, and baths were located on the second floor. Donations from citizens, city officers, and local representatives of the Insurance Underwriters, the *Chronicle*, and the *Herald* made it possible to equip the third floor with a complete gymnasium, two pool tables, and an emergency (hospital) room for giving medical aid to fireman injured at a fire. (*Year Books* 1909 and 1910.)

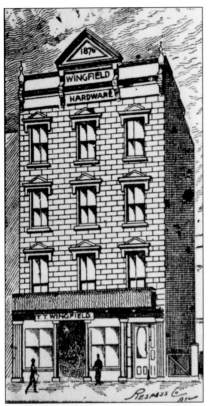

The Wingfield Hardware Company, at 1027 Broad Street, in 1900. The proprietors were Thomas T. Wingfield, James G. Wingfield, Frank P. Wingfield, and Edward B. Wingfield. The Wingfields were dealers in hardware and carriage and wagon material. The address changed to 1043 in 1904. The site is now a vacant lot.

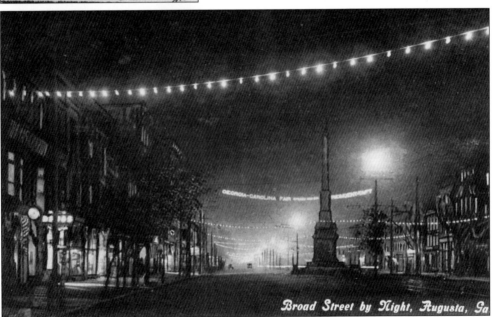

The 700 block of Broad Street, November, 1909. The sign advertises the Georgia-Carolina Fair and a visit from President William Howard Taft. The card message reads: "It is night. We are all waiting to see Pres. Taft who will be here in an hour. This street is covered for a mile with bunting and red, white and blue electric lights."

Two
Street Scenes

Greene Street, Augusta's street of churches, monuments, and homes, was well depicted in postcards, as were Reynolds Street, Telfair Street, and Jackson (Eighth) Street. We will continue our tour with these and other street scenes.

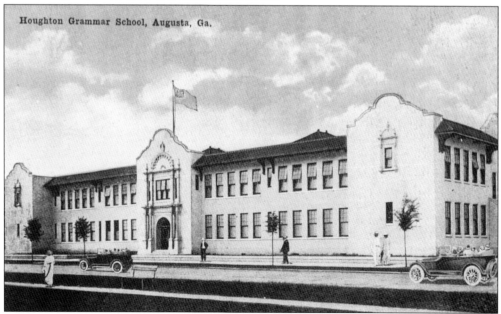

Houghton Grammar School, 333 Greene Street. The school was built in 1916 at a cost of $60,000 after the original school burned in the 1916 fire. G. Lloyd Preacher was the architect. The school was named as a memorial to John W. Houghton, who funded the original building as a free school for poor children. His remains rest in a crypt in the entrance of the building.

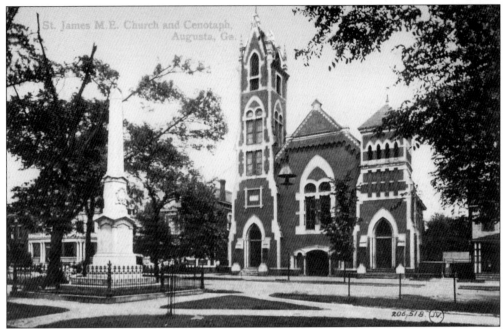

St. James M.E. Church (Methodist) and Cenotaph at 439 Greene Street. Built in 1856, the church has been renovated twice, with the Gothic features being added in the 1880s. The cenotaph was erected by the St. James Sunday school in memory of the 24 church members and the 292 men from Richmond County who died in the Civil War. It was dedicated on December 31, 1873, and was reportedly the first Confederate monument in the South.

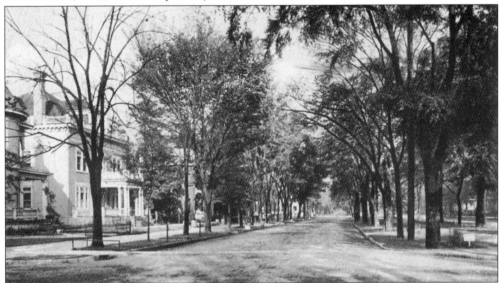

The south side of Greene Street, looking west from Centre (Fifth) Street, c. 1905. The portion of the house at 502 on the southwest corner that can be seen in this view was the home of William C. Cleckley, D.D.S. His office was in his home. The next house at 510 was the residence of Henry C. Perkins, the president of Perkins Manufacturing Company and Georgia Iron Works. The house at 510 is the only house remaining between the corner and the courthouse.

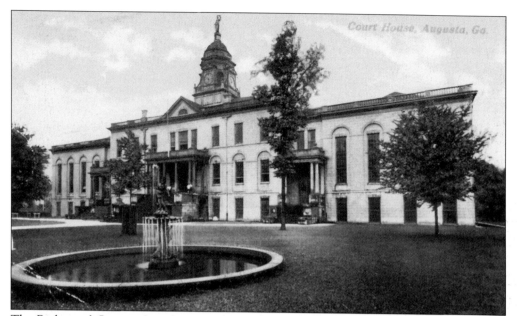

The Richmond County Courthouse, at 530 Greene Street, *c.* 1915. The central portion was built in 1820, and the wings were added in 1892. The building was demolished when a new Augusta-Richmond County Municipal Building was constructed on the site in the mid-1950s. The card message reads: "How would you like to work in a building like this. The people are so slow you would not like this place. They would be in your way. You would have to walk over top of them. Can tell you more in my letter."

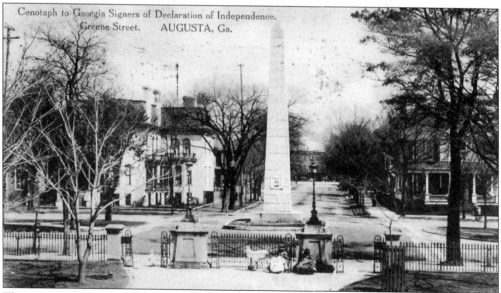

The Cenotaph to Georgia Signers of Declaration of Independence, located at Greene Street in front of the courthouse at the intersection of Monument Street, *c.* 1910. The cornerstone was laid July 4, 1848, and the bodies of Lyman Hall and George Walton were interred in the base. The remains of Georgia's third signer, Button Gwinnett, have not been located. The monument was designed by Robert French of New York and built of Stone Mountain granite. The house across the street on the left at 551 Greene Street still stands.

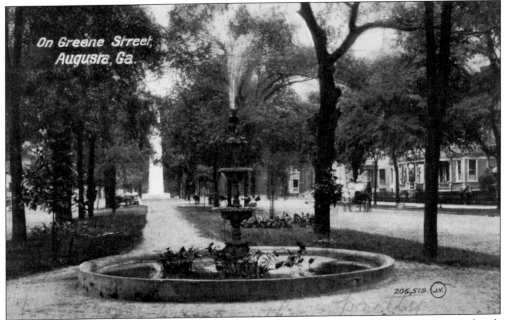

The park in the 500 block of Greene Street, looking west, c. 1906. In 1902, Mayor Jacob Phinizy proposed that the citizens on Greene Street purchase fountains for the parks. The City would then install them and provide free water in an effort to beautify the city streets. He also proposed to curb the greens, which the City did the next year. The card message reads: "This is one of the prettiest streets in Aug. Would like to hear from you again."

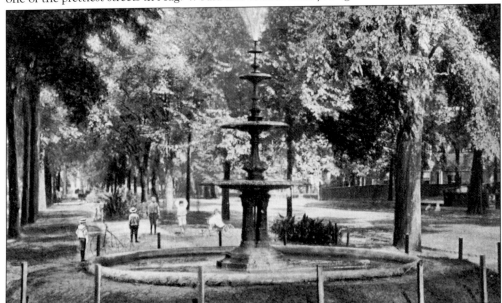

The Martin Fountain, c. 1903. The caption message reads: "The Martin Fountain, on Martin Square, Lower Greene St., was erected by the public to the memory of Alfred M. Martin, ex-Mayor of Augusta. It was completed in February, 1902. It is made of iron, is 12 feet high, and consists of three pans." Other than this, very little information can be found about the fountains on Greene Street.

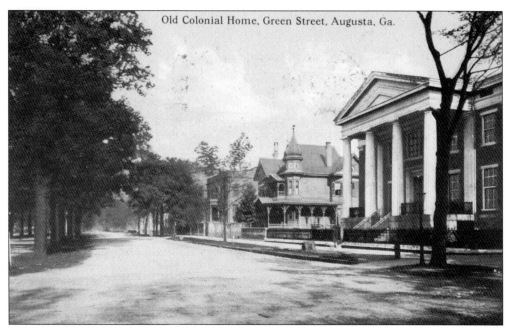

Old Colonial Home, Green Street, Augusta, Ga.

The north side of Greene Street, looking west from Centre (Fifth) Street, *c.* 1901. The four-column house at 503 was the residence of Dr. Thomas D. Coleman. The second house at 509 was the residence of Harris H. D'Antignac. The 500 Office Building now occupies the site of both homes.

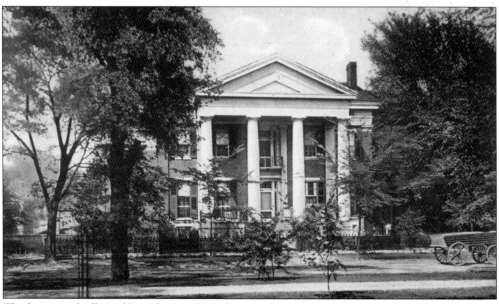

The home and office of Dr. Thomas D. Coleman, physician and surgeon, at 503 Greene Street, *c.* 1903. His office hours were "2:30 to 4:30 pm, Sundays excepted; other hours by appointment only." He was also associated with the Pine Heights Sanitarium in North Augusta. The card message reads: "This is Dr. Coleman's house almost opposite us if you remember."

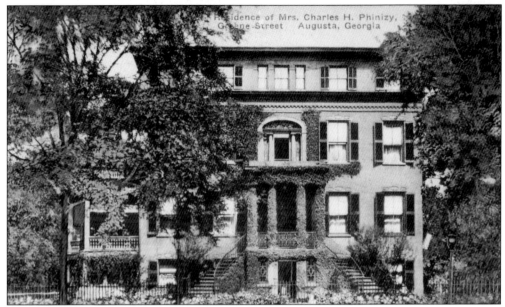

The residence of Mrs. Charles H. Phinizy, at 519 Greene Street, *c.* 1920. The card caption reads: "A home in early Augusta. Built in 1841 by Mr. John Phinizy and at his death, passing to his son, the late Mr. Charles H. Phinizy." However, other sources say the home was built in 1835. The building has subsequently been used as a funeral home, an Elks Lodge, and recently as a conference/reception center.

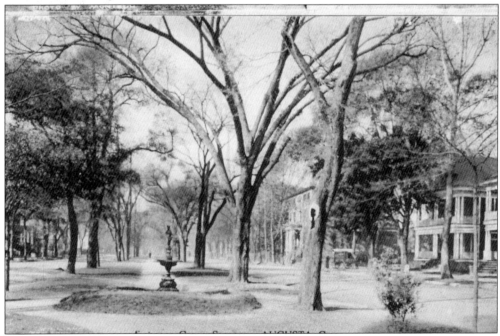

Fountain view in the park in the 500 block of Greene Street, looking west from Monument Street, *c.* 1912. The houses on the right, which no longer exist, were boardinghouses. The card message reads: "Hello Bill, Some burg Augusta. Lots of women. Are treated fine by citizens of Augusta."

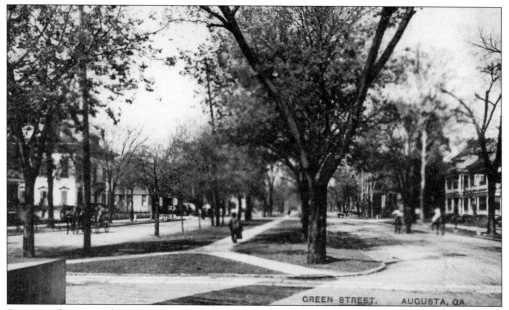

Same park as in the previous view, but without the fountain. The base of the Signers Monument is in the left, lower corner. The card message reads: "522 Greene St., March 22. (Residence of D. Franklin Jack) Arrived here on the 7th and have been the guest of my cousin in a spacious house on this Greene St. They have a fine automobile and we go out daily in it thus having much pleasure. We leave tomorrow."

The 600 block of Greene Street looking west, c. 1910. The beautiful steps lead to number 610, the residence of Mrs. Anna E. Branch, the widow of Thomas P. Branch. The second house at 616 was the residence of Mr. Joseph C. Fargo. The third house at 624 was the residence of Mrs. Annie C. Baker, the widow of Dr. Archibald H. Baker. The fourth house, with the gazebo, at 628 was the residence of J. Frank Carswell. All are gone except 624, which now has a modern facade.

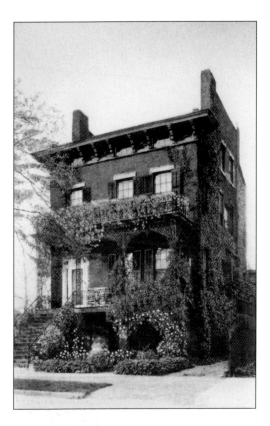

613 Greene Street, *c.* 1920. The card caption reads: "A historic home in Augusta. Built about 1850 by Maj. J.V.H. Allen, and used for military purposes during the war between the states." The home was the residence of Archibald Blackshear, attorney, in 1920. Previously the home of Dr. J.E. Allen for many years, the site is today a vacant lot.

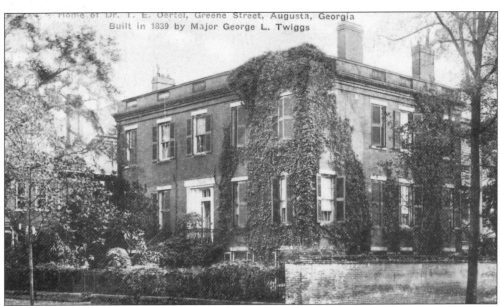

The home of Dr. T.E. Oertel, at 638 Greene Street, *c.* 1920. The home was built in 1839 by Major George L. Twiggs, although some sources say it was built in 1810. In the late 1930s, it was the Southern Hall tourist home for overnight guests. It was demolished about 1950 to make way for the Trailway Bus Station.

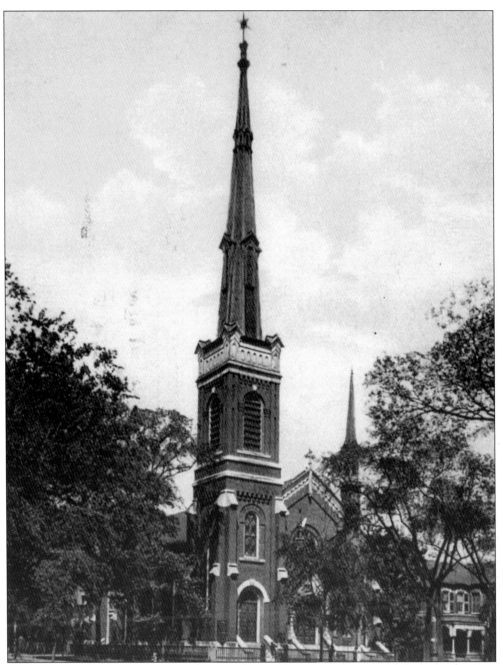

The First Christian Church at 629 Greene Street, at the northeast corner of Greene Street and McIntosh (Seventh) Street, c. 1906. The building was designed by Macon architect D.B. Woodruff and was built between 1874 and 1876 by contractors T.O. Brown and William H. Goodrich. The church was a gift from Mrs. Emily Tubman, a member who had previously provided the congregation with their first church building on Reynolds Street (First Christian Church Brochure, Dr. Don C. Manning). The card message reads: "Genesta Hotel. Expect to be in my home in a few days. My address is 222 Greene St. We are feeling fine after our trip. Had beautiful weather all the time."

Residences on the north side of the 700 block of Greene Street looking east, *c.* 1906. The First Christian Church steeple is in the background. The closest house was number 709, the residence of Charles A. Doolittle, of C.A. Doolittle and Son storage warehouse. The lady walking up the street was in front of number 705, the residence of dentist George A. Patrick. The last house at number 701 was the residence of Richard E. Allen, the mayor of Augusta.

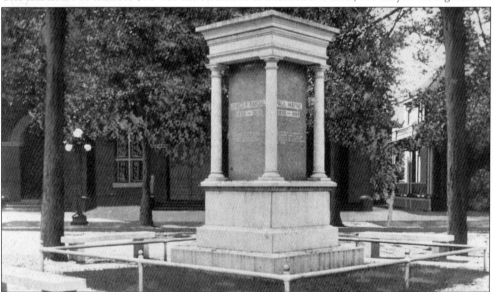

The Poets Monument in the 700 block of Greene Street, *c.* 1915. The monument was unveiled in April 1913. The card caption from another card reads: "Four Southern Poets. A monument recently unveiled in Augusta, Ga. is stimulating interest in the literature of the South almost as much as the protest against an American literature textbook in which only two of the twenty-eight portraits are of Southerners. The Augusta memorial, given by Mrs. E.W. Cole of Nashville, bears the names of four poets a few Southern journalists describe as the South's 'four greatest': Sidney Lanier, 1842–1880; Father Abram J. Ryan, 1842–1886; James R. Randall, 1839–1908; Paul Hayne, 1830–1886."

The St. John Methodist Church at 736 Greene Street, *c.* 1906. The church was organized in 1798, and the present church building was constructed in 1844. Their first church, which had been built in 1801, was then sold to the Springfield Baptist Church and moved to the corner of Reynolds Street and Marbury (Twelfth) Street, where it continues in use today.

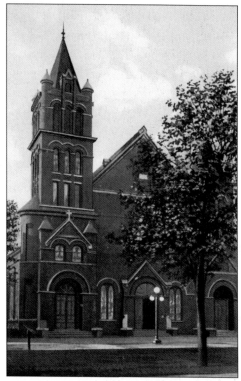

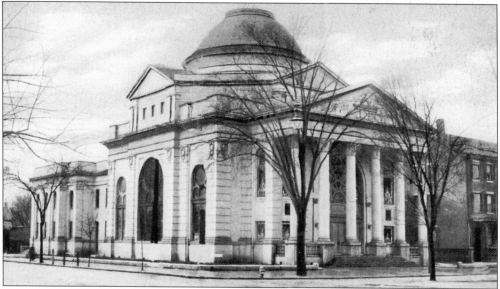

The First Baptist Church on Greene Street, on the southwest corner of Jackson (Eighth) Street, *c.* 1906. At that time, the house next door was a duplex. This building was constructed 1902–1903 and replaced the first church, which had been built 1820–1821. The church moved out on Walton Way in the early 1970s. The card message reads: "We are back in Augusta to stay this summer at least. Very warm here today. I went to an Easter egg hunt with a lady friend and her children, and I went flower picking while they hunted eggs, got a large bouquet of yellow jasmine."

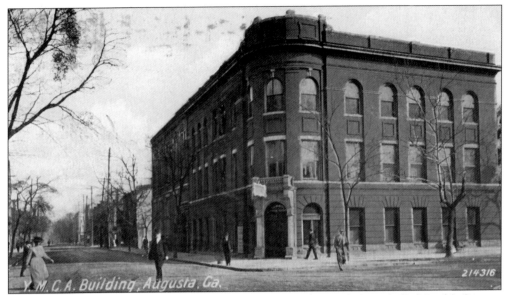

The YMCA Building on the northeast corner of Greene and Campbell (Ninth) Streets, c. 1908. The rear portion was built in 1891, and the front portion, in 1892. The building featured a gymnasium in the rear section, a hall on the second floor, and rooms on the third floor. After the YMCA moved to their new building on Broad Street in 1923, this building was converted to the Margaret Hamilton Hotel. The site is now the Municipal Parking Plaza.

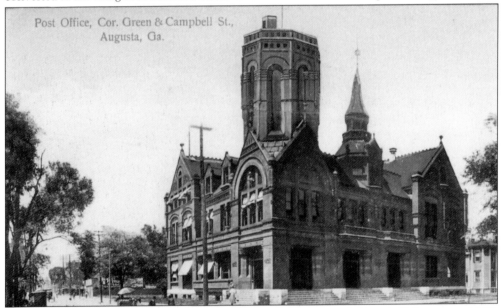

The Post Office Building on the southwest corner of Greene and Campbell Streets, c. 1900. The building was designed by the office of the supervising architect of the Treasury Department during the Romanesque architecture period. On May 10, 1888, *Harpers Weekly* reported, "The building at Augusta is very beautiful and difficult to classify, and inclines to the English Gothic." The building was completed in 1890. The post office moved in 1916, and the building was converted to city offices in March 1917. The structure was demolished, and a public library was built on the site in the late 1970s.

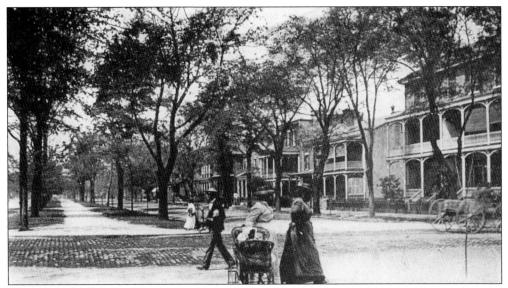

The north side of the 900 block of Greene Street at Campbell Street, across from the post office, c. 1905. The first three houses, at 903–905, 909–911, and 913–917, were duplex-style houses with two families in each. Dr. William H. Doughty, physician, had his office in his home at number 903. His neighbor at number 905 was Charles Estes, vice-president of the John P. King Manufacturing Company. This large duplex home was three stories tall with two-story wings off each side at the rear. They no longer exist.

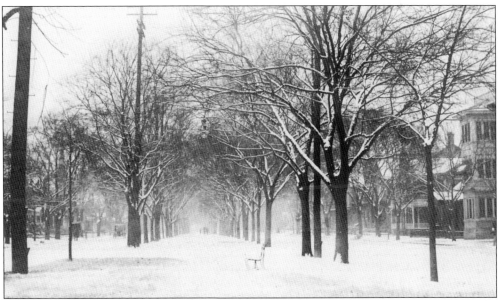

Snow-covered park in the one thousand block of Greene Street, December 31, 1917. The Shirley Apartments at 1001–1005 are at the right-hand edge. The card message, from February 7, 1918, reads: "Here is a slight idea of the winter here; nothing comparred [sic] to the north. Is it? I hope this finds you enjoying the sleighing. It is quite nice here now."

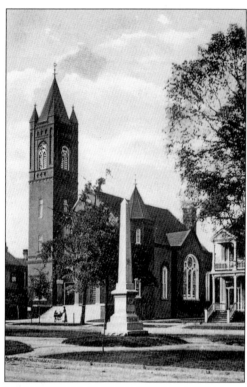

The Greene Street Presbyterian Church, at 1235 Greene Street, and the Richard Henry Wilde Monument, c. 1905, just after the church was built. Formerly known as the Second Presbyterian Church, the name was changed when this building replaced the old wooden structure. The Wilde Monument was moved to the 800 block of Greene Street when the Calhoun Expressway was built, intersecting Greene Street at this point.

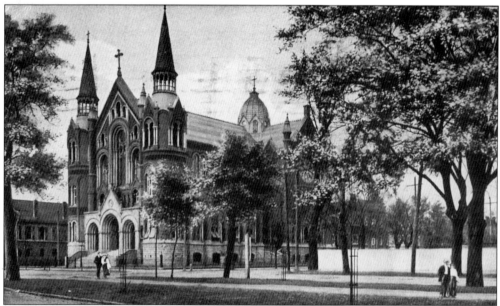

The Sacred Heart Catholic Church, at the northwest corner of Greene Street and McKinne (Thirteenth) Street, c. 1906. The church was dedicated on December 2, 1900, and the last service was held on July 4, 1971. It is now the Sacred Heart Cultural Center. The card message reads: "This is where I went to church today. Wish "you all" had been with us. Has been hot today but had a nice breeze. Margaret and I took a ride yesterday and visited the U.S. Arsenal and 'the hill.' Looks sort of flat here after seeing N.C."

50

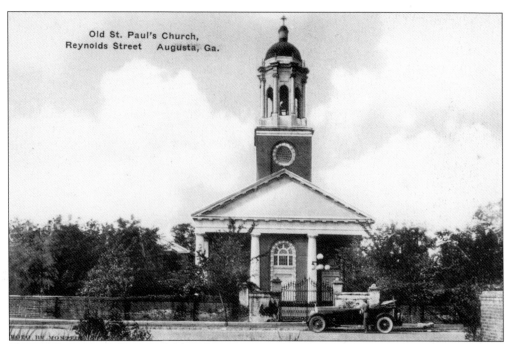

Old St. Paul's Church,
Reynolds Street Augusta, Ga.

Historic Saint Paul's Episcopal Church at 605 Reynolds Street, c. 1920. The fourth and current building was completed in 1919 to replace the old 1820 structure that was destroyed in the 1916 fire. H.T.E. Wendell was the architect. The old church was a familiar Augusta landmark, and Wendell copied it in his design with only minor changes. Rev. Sherwood G. Whitney, rector of St. Paul's, mailed a view card of the church to Rev. James B. Lawrence, of Americus, Georgia, on November 19, 1908, which reads: "By all means send me an account of your trip to Blakely. I overlooked that part of your letter in writing. Yours faithfully."

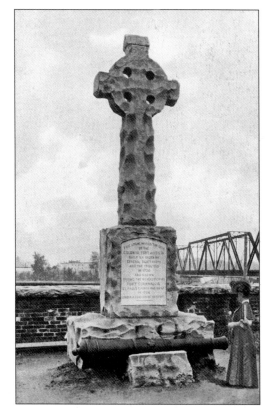

The Celtic cross in the back of St. Paul's Church, c. 1908. The cross, erected by the Georgia Colonial Dames as a memorial to the site of Fort Augusta, was unveiled on November 24, 1901. The Southern Railroad bridge and buildings in Hamburg, South Carolina, are visible in the background.

51

Tubman High School for Girls at 711 Reynolds Street, *c.* 1912. Thomas Harry Garrett was the principal. The building, twice expanded, was originally the First Christian Church. Mrs. Emily Tubman provided the building for the school when she built a new church on Greene Street. The card message reads: "My dear: We have been here a week enjoying the warm days, sunshine, birds & flowers. I am sitting on the piazza now writing this card & enjoying every minute. It is delightful here. Hope to stay here a long time but I am afraid not."

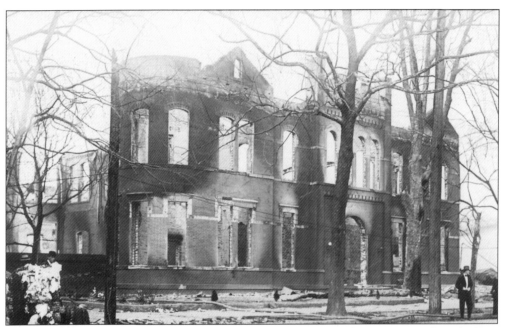

Tubman High School as it appeared after the March 1916 fire. Classes continued in the First Presbyterian Church Sunday school building until a new school was built on Walton Way two years later.

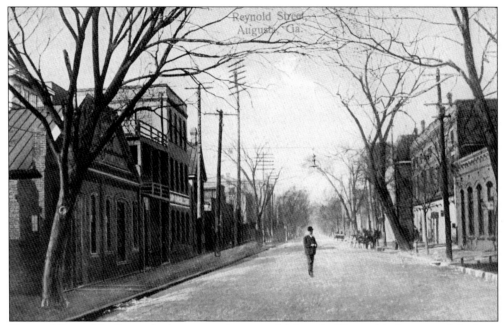

View of Reynolds Street looking west between McIntosh (Seventh) Street and Jackson (Eighth) Street, c. 1908. The building at the left edge is the rear of Day and Tannahill, whose offices were on the ground floor of the Commercial Club building on Broad Street. The building at the right edge is the office of Pope and Fleming Cotton Factors. Both sites are now asphalt parking lots.

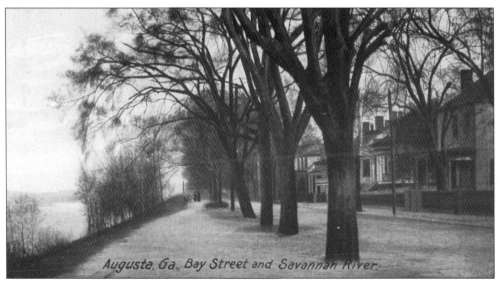

A view of Bay Street and the Savannah River, looking east between Centre (Fifth) Street and Elbert (Fourth) Street, c. 1906. These houses were moved back 70 feet in 1915 to accommodate the levee, and they all burned in the 1916 fire.

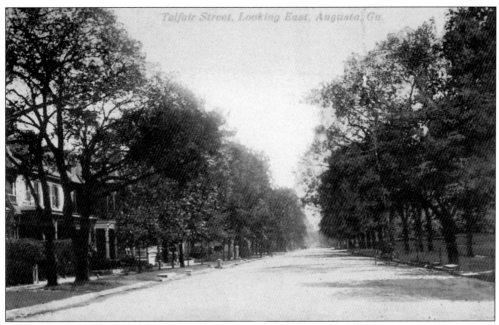

Telfair Street looking east. This view of the tree-lined street is probably to the east of Centre (Fifth) Street.

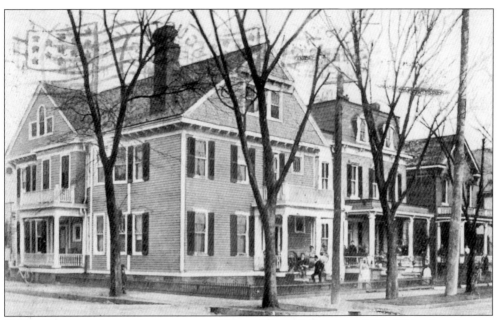

Telfair Street, at the northeast corner of Elbert (Fourth) Street, c. 1907. This view shows a duplex with addresses on both streets. 355 Telfair was the residence of George W. Bosman, a buyer for C. Cochrane and Company, cotton exporters. 422 Elbert was the residence of Mrs. Mary T. Acton, the widow of William D. Acton. The other two houses were 353 and 349 Telfair. They survive and were included in the Telfair Square plan for Olde Towne.

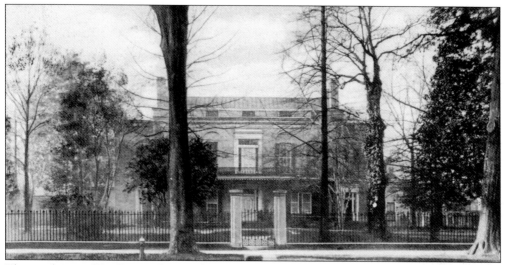

The residence of Dr. Eugene E. Murphy at 432 Telfair, also known as the Government House, c. 1920. Built in 1801 for use as the county courthouse and meeting place for the city council, the structure was sold by the City in the 1820s to Samuel Hale. It was subsequently purchased in 1839 by Col. Paul Fitzsimmons, who added the wings. The Murphy family owned the home from the mid-1870s to the mid-1950s. The building was bought back by the City in 1987 and renovated.

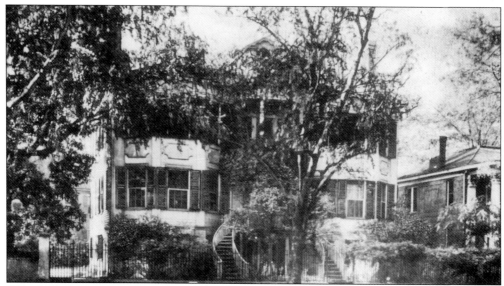

"Ware's Folly" at 506 Telfair, the southwest corner of Telfair and Centre Streets. The structure was built in 1818 for Nicholas Ware, a future Augusta mayor. It got its name because of the large sum, $40,000, spent for construction. Today, it is the Gertrude Herbert Institute of Art. (Photo by Montell, c. 1920.)

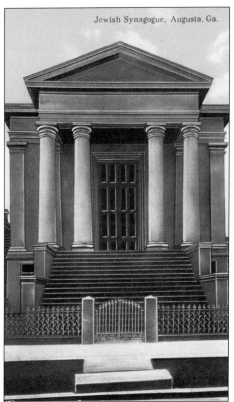

Jewish Synagogue, Augusta, Ga.

The Jewish Synagogue at 525 Telfair, *c.* 1915. Built by the Congregation of the Children of Israel, the structure was completed in 1872. The congregation moved to Johns Road in 1951. The building was remodeled in 1960 for use as an office building, and it is currently occupied by the Augusta-Richmond County Planning Commission.

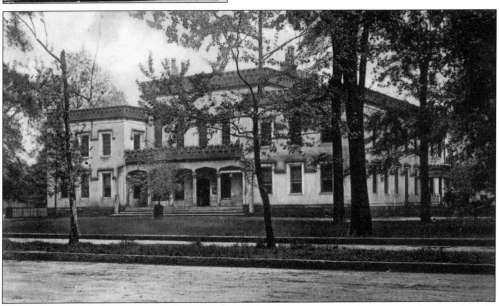

The Academy of Richmond County at 540 Telfair, *c.* 1906. Built in 1802 to replace the old building on Bay Street that had been in use since 1785, the Academy was remodeled in 1856–1857 by William H. Goodrich. The structure served as a Confederate hospital during the Civil War. The school moved to Baker Avenue on the Hill in 1926, and this building was subsequently used as a library and a museum.

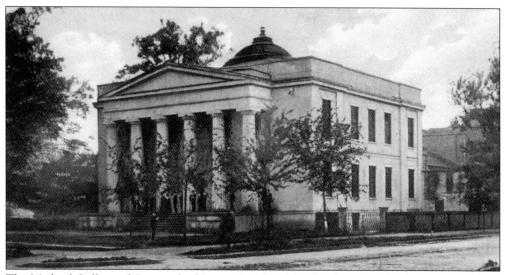

The Medical College of Georgia building at 598 (560) Telfair Street at the southeast corner of Washington (Sixth) Street, c. 1905. The building was constructed from 1834 to 1835, and Charles B. Cluskey was the architect. The Medical College moved to the Orphan Asylum building on Railroad Avenue (now R.A. Dent Boulevard) at Harper Street in 1912. The property then reverted to Richmond Academy, which held classes in the building until 1926. Subsequently used by various civic and social organizations, the building was restored by the Medical College of Georgia Foundation in 1990.

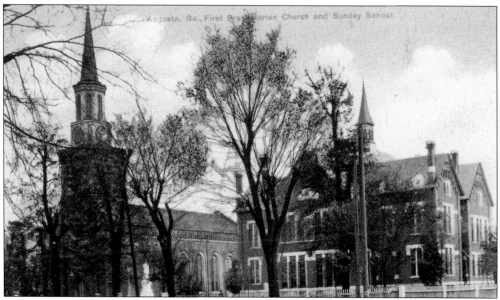

The First Presbyterian Church, at 642 Telfair. The church was constructed from 1809 to 1812, and it was designed by architect Robert Mills, who also designed the Washington Monument. President Woodrow Wilson's father, Rev. Joseph R. Wilson, D.D., was the pastor from 1858 to 1870. The Telfair Building, on the right, was dedicated in June 1884 as a memorial to Miss Mary Telfair. It served as the Sunday school and library, but was torn down in the 1970s. The card message reads: "What do you think of the church I go to, its much prettier than this card pictures it."

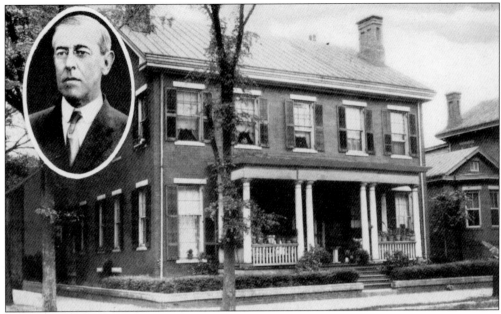

The boyhood home of President Woodrow Wilson at 419 McIntosh (Seventh) Street, at the northwest corner of Telfair, c. 1917. The building was acquired in 1860 by the church to be the new manse for Wilson's father, Rev. Joseph R. Wilson, D.D. The house is currently being restored by Historic Augusta.

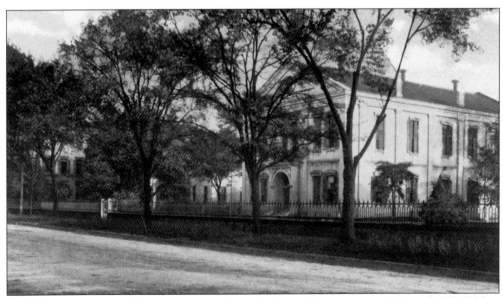

St. Mary's School for Girls and St. Patrick's Commercial Institute at 708 and 722 Telfair, c. 1908. St. Mary's building can barely be seen through the trees. The Institute building on the right was the old Church of the Most Holy Trinity, which had moved into a new structure next door in 1863. Bell Auditorium is on the site off St. Patrick's Institute. St. Mary's was converted to Boy's Catholic High School in 1939 and operated until 1957, when it moved to Aquinas High School on Highland Avenue. The site is now a parking lot.

St. Patrick's Catholic Church, at 720 Telfair, on the southeast corner of Jackson (Eighth) Street, c. 1906. Consecrated as the Church of the Most Holy Trinity in 1863, the church was commonly known as St. Patrick's until the three downtown parishes were consolidated in 1971. St. Patrick's was chosen to head the parish, and it re-established as its official name the Church of the Most Holy Trinity.

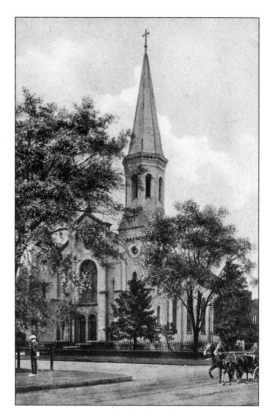

The Church of the Atonement (Episcopal) at 1018 Telfair on the southeast corner of Kollock (Eleventh) Street, c. 1920. The church was built from 1850 to 1851 with money provided by R.H. Gardiner Jr., his wife, Sarah Fenwick Jones, and her sister, Mary Gibbons Jones. In 1853, Robert McKnight, great-grandfather of the author, was the twenty-fourth member to join. The author's grandparents, Joseph M. Lee and Mattie Ann McKnight, were married there May 6, 1896. In an *Augusta Chronicle* article about the church published on June 11, 1944, Mrs. Mary G. Cumming wondered if the church was "waiting, perchance, for the fulfillment of its final destiny." Sadly, that destiny was its demolition—to make room for a used car lot.

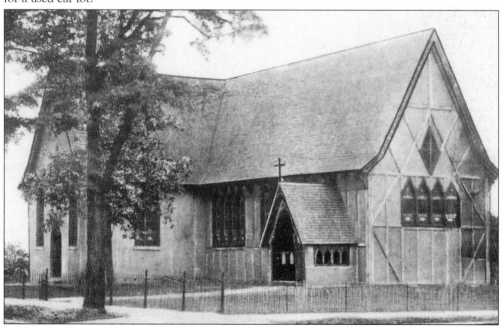

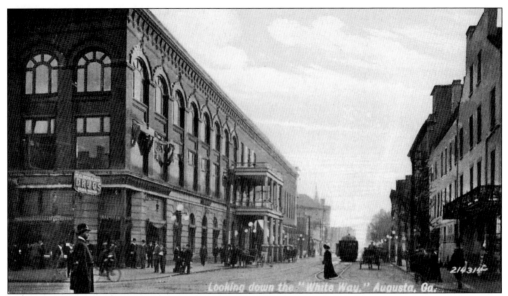

The "White Way," Jackson (Eighth) Street, looking south from Broad Street, *c.* 1915. Augusta was proud of its streetlights, and several postcard street scenes promoted their night time illumination. T.G. Howard Drugs now occupies the corner store of the Miller-Walker Building, which was previously the Savoy, where T.G. Howard was also the proprietor.

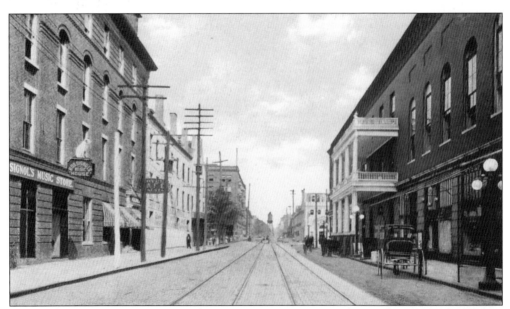

Jackson (Eighth) Street looking north from Ellis Street, *c.* 1910. The Miller-Walker Building is on the right. "Rossignol, The Music Man," or Charles F. Rossignol, had his store at 223 Jackson Street for a few years. He sold pianos, Edison phonographs, and Victor Talking Machines.

The Hotel Genesta at 215 Jackson (Eighth) Street, c. 1917. The hotel's proprietors were Stulb and Vorhauer. A 1913 advertisement boasted: "Right in the heart of the retail shopping district. Everything strictly first class. Elegant Cafe, private dining rooms. Every convenience for ladies while shopping in Augusta. Elegant ladies' Restaurant up stairs." The Genesta operated from 1905 to 1932, when it became the Hotel Clarendon. You can still see an ad for the hotel on Ellis Street on the side of the building at the northwest corner of Jackson Street.

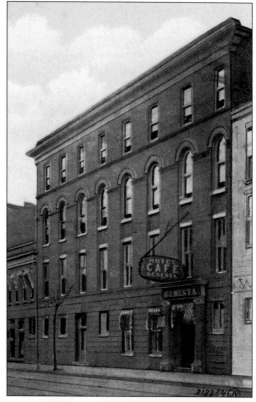

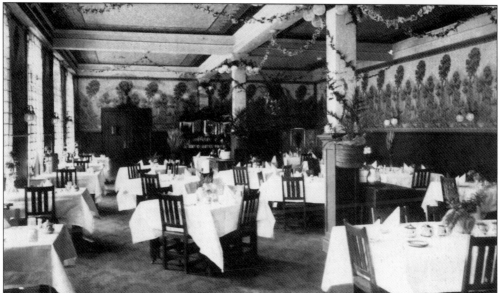

Hotel Genesta dining room, c. 1908. Elegantly furnished, with every modern convenience, the dining room appears in an ad which stated: "Standard European Cafe of the South. Exclusive and refined Dining Room for Ladies. Elegant Cafe and Smoker for Gentleman. Dining room opens 6 a.m., closes 9 p.m. Breakfast club plan 25 cents and up. Lunch, Table d'Hote ,week days only, 50 cents. Sundays, Table d'Hote Dinner 75 cents."

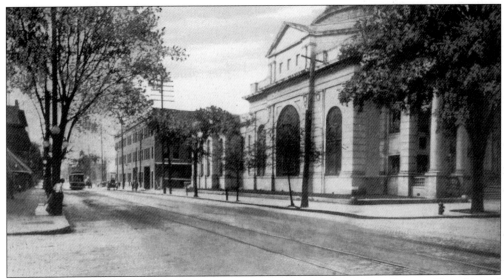

Jackson (Eighth) Street, looking south from Greene Street (from First Baptist Church) and showing the new Electric Car Company's Terminal Building, c. 1910.

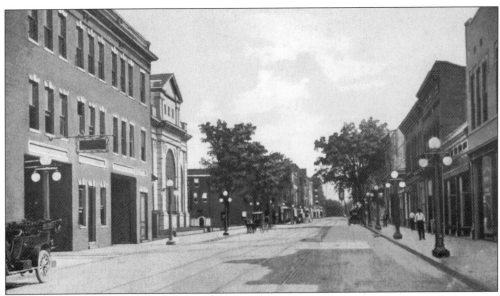

Jackson (Eighth) Street, the White Way, looking north from Telfair Street, c. 1912. The Augusta-Aiken Railway and Electric Corporation terminal building at 801 Telfair Street is on the left, and it housed the offices of the corporation. It was converted to the Terminal Hotel in 1921 and the Jackson Hotel from 1939 to 1965. The site is now a vacant lot.

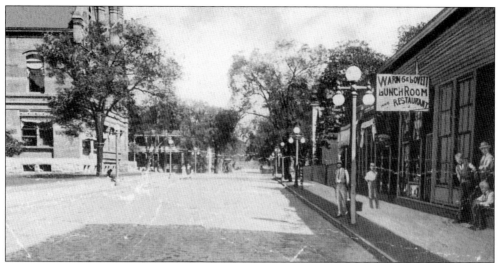

The White Way, Campbell (Ninth) Street, c. 1915, looking north from Telfair Street. The post office building is on the left at the southwest corner of Greene Street. African-Americans John P. Waring and Arthur Lovett operated a restaurant at 422–424 Campbell Street, c. 1915. The card message reads: "Oct. 15, 1916. This is the Main Street running from Union Station to Broad St. Augusta is not dead now. Several thousand people visited the city yesterday. Trade was busy."

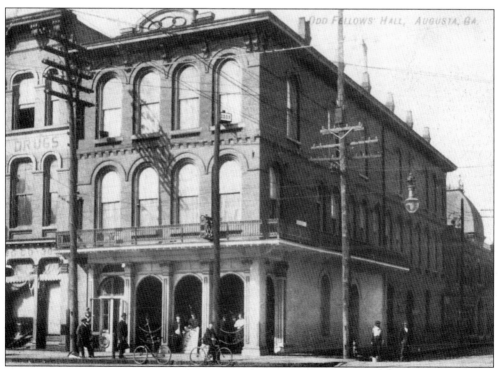

Odd Fellows Hall at the southwest corner of Jackson (Eighth) Street and Ellis Street c. 1905. Independent Order Odd Fellows was a fraternal order that occupied the second and third floors. James Campbell had a saloon in the store on the ground floor. The building still stands.

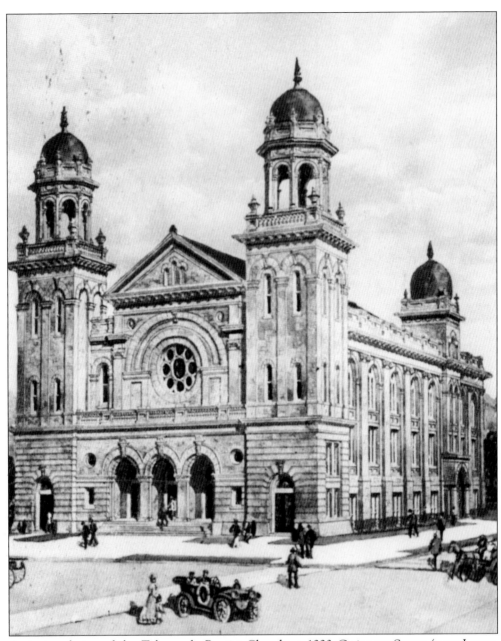

Artists rendering of the Tabernacle Baptist Church at 1223 Gwinnett Street (now Laney-Walker Boulevard). The church, founded in 1885 by the Rev. Charles T. Walker, was built on the site of the Lamar Hospital after the hospital burned in 1911. On December 21, 1913, the *Augusta Chronicle* reported that work was progressing nicely. "For 3 weeks men have been laying bricks—130,000 yet the structure is still 4–5 feet below street level. The whole building will take 1,500,000 bricks." The church was completed in 1915. The cost of the structure was $100,000, which the church paid off by 1919. The church remains active today. This card was published by John F. Dugas.

Three
Points of Interest

Business and industry, especially cotton, the canal, the river, hospitals, and schools, will be covered in this chapter.

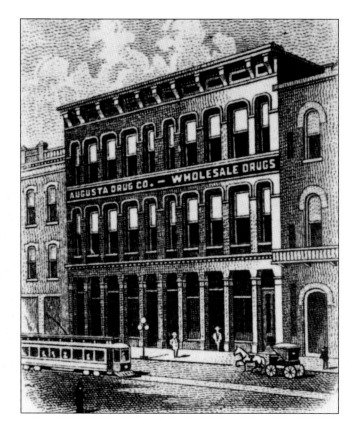

Augusta Drug Company, Wholesale Drugs, at 305–309 Jackson (Eighth) Street, from a 1915 invoice. John Phinizy was president and treasurer; Nathaniel L. Willet was vice-president (and president of the N.L. Willet Seed Co.); John W. Haley Jr. was secretary; and William B. Marks was manager (and treasurer of N.L. Willet Seed Co.). The Odd Fellows building is next door. This building still stands.

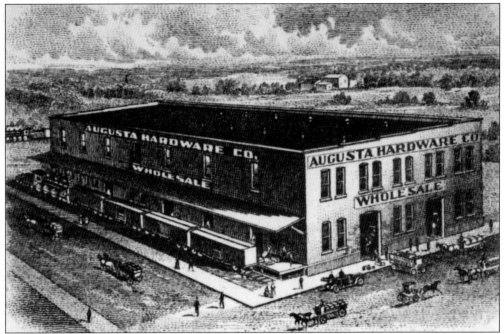

The Augusta Hardware Company, Wholesale hardware, at the southwest corner of Washington (Sixth) Street and Reynolds Street, from a 1911 invoice. M. Burton Hatcher was president, Eugene M. Fuller was general manager, and James A. Anderson was secretary-treasurer of the company. The company, located across Reynolds Street from St. Paul's Church, burned in the 1916 fire.

Clark Milling Company at the southwest corner of McKinnie (Thirteenth) Street and Fenwick Street, next to the canal gatehouse, from an early invoice. The company was founded in 1898. A 1904 ad listed their products: "Flour, Meal, Grits, Bran, Shipstuffs. Chicken Feed a Specialty. Hotel Bon Air and Hampton Terrace use our Flour. High Grade Products. Ask for Prices. Capacity 800 Barrels Per Day." The building has since been demolished, and the site is vacant.

Georgia Chemical Works, located on the south side of Gwinnett Street (now Laney-Walker Boulevard), directly across where Washington (Sixth) Street intersects, from a *c.* 1900 ad. Manufacturers of fertilizers and acid phosphates, they advertised themselves as the largest fertilizer factory in the South. Some of their products were Mastodon Guano, Grain Fertilizer, Lowe's Georgia Formula, Dissolved Bone Potash, and Acid Phosphate with 4 percent potash. Every bagful weighed 200 pounds.

Hildebrandt's at 226 Washington Street, at the northeast corner of Ellis Street. Taken from a envelope mailed January 11, 1902, the envelope lists N. Hildebrandt as a dealer in "Fancy Groceries, Produce, Fish, Oysters, Game & Ice, 221–223 Washington Street" (address numbers changed in 1904). According to the *Augusta Chronicle-Herald* on November 14, 1982, "the company was founded by Nicholas Hildebrandt in 1879. He built the store at a cost of $10,000 in gold. The store is an Augusta institution, having been operated by the Hildebrandt family for several generations." The store is still in operation.

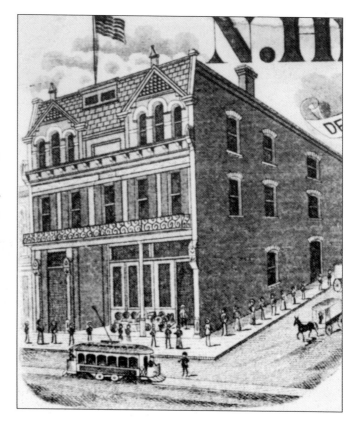

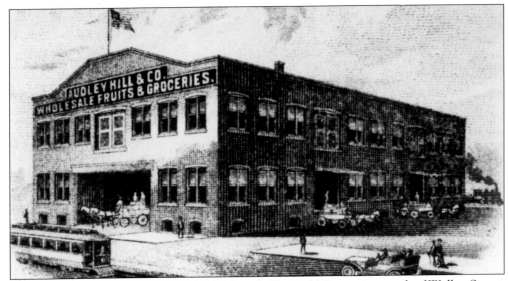

Audley Hill and Company, at 630–634 McIntosh (Seventh) Street, just south of Walker Street, in what was called the Triangular Block. According to a 1911 invoice, Audley Hill and Co. was known for "Wholesale Fruits, Produce, Groceries and Field Seeds. Audley Hill, Proprietor." This invoice requested two barrels of cabbage for $3.00, one bunch of bananas for $1.50, one sack of G.M. potatoes for $2.20, and one box of Sticky Fly Paper for $2.50. The site is now part of the parking lot for the Civic Center.

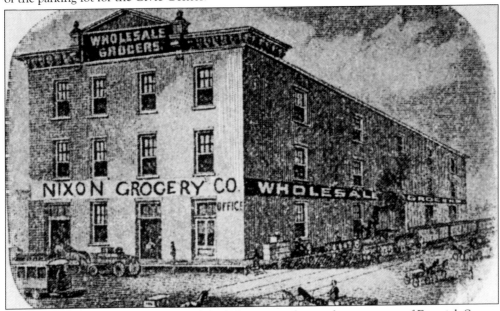

Nixon Grocery Company, at 629 McIntosh Street, on the northwest corner of Fenwick Street. A 1905 invoice gives the information that the company was a wholesale grocer, was a dealer in grain and hay, and was the proprietor of the Crescent Mill. J. Slidell Nixon was president, and William M. Nixon, secretary and treasurer. The building was set on fire during the 1908 flood when water came in contact with lime stored in the warehouse. Five people in the warehouse drowned when they tried to escape the fire, including Harry Carr, the bookkeeper, who could not swim and was swept away when an attempt to pull him to safety with a rope failed.

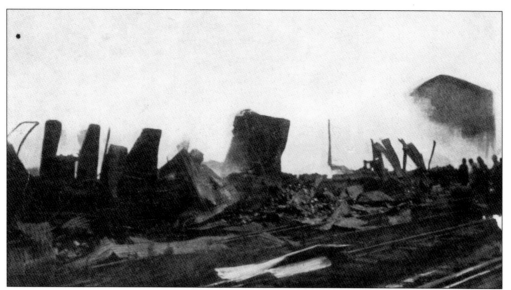

The remains of the Nixon Grocery Company after the 1908 flood and fire. Today, the site is a vacant lot.

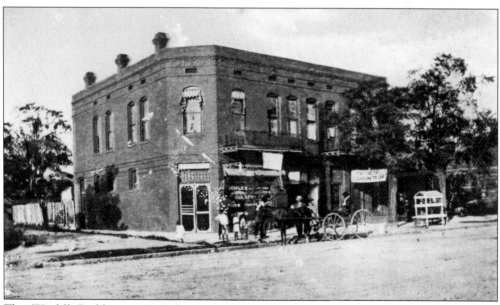

The Wigfall Building at 919 Gwinnett Street (now Laney-Walker Boulevard), c. 1920. Clarence S. Wigfall was an African-American grocer who had previously operated a business on upper Broad Street. This card was published by John F. Dugas.

Southern Express Co., 736 Broad Street and Union Depot. A note on the back of the photograph signed by Hugh Dempsey, division superintendent, explains: "Two Noble Bays. Two bay horses, 'Baby' and 'Starr', each four years old when bought by Southern Express Company at Augusta, Ga., March 27, 1883, from Mr. Franklin of Gallatin, Tenn. Price paid, $543.00. These horses have been and are still in continuous service at Augusta, Ga. The are in good health and look well as shown in the picture, which was taken on March 27, 1903, twenty years from date of purchase."

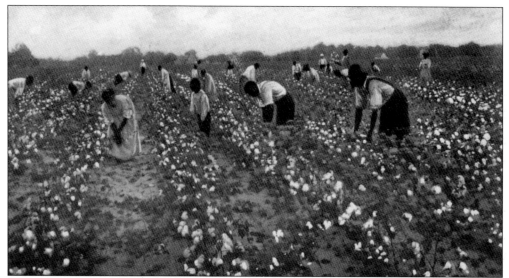

Cotton picking, *c.* 1905. Augusta was known as the South Atlantic cotton center and the second largest inland cotton market in the world in the early 1900s. Promoters labeled it "The Lowell of the South." In 1908, there were thirteen cotton mills, employing over 6,500 people and consuming 115,000 bales of cotton in the process. There was also a large market for the shipment of cotton seed for planting (Augusta Chamber of Commerce 1908). There are many Augusta postcards with a cotton-related theme.

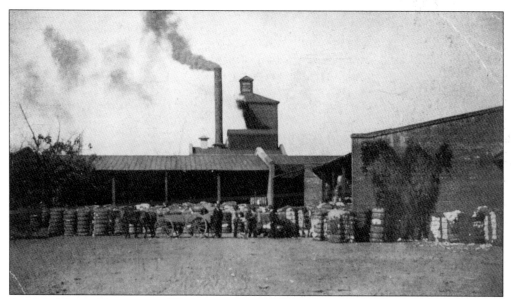

Augusta Cotton Compress on Washington (Sixth) Street between Calhoun Street and Taylor Street, *c.* 1900. The compress had a capacity for the storage of 4,700 bales of uncompressed or 8,200 bales of compressed cotton. There were two powerful compresses with a capacity of 150 bales per hour. The business was later known as the Doughty Compress Company.

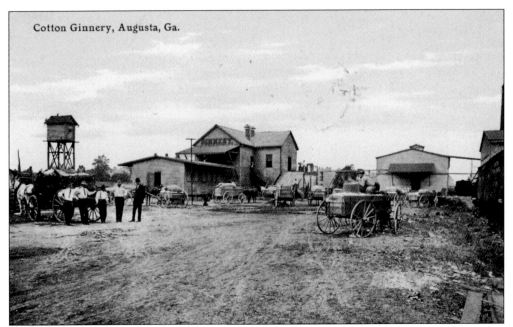

Cotton Ginnery, Augusta, Ga.

Cotton Ginnery, Planters Cotton Oil Company, at 1855 Milledgeville Road (now Martin Luther King Jr. Boulevard), c. 1910. The Planters Cotton Oil Company was a manufacturer and exporter of cotton seed products. A short article in the *Augusta Herald* on September 22, 1940, stated that the company was a pioneer in the cotton seed oil industry in this area. The business was started in 1900 by the firm of Pope and Fleming. Porter Fleming was the president and treasurer in 1905. Technochem is located on the site today.

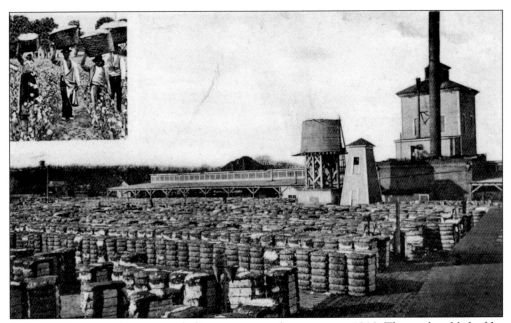

A cotton scene near Augusta, including an unnamed company, c. 1910. The card, published by Miss W.D. Thomas, may feature the Augusta Cotton Seed Oil Company at 1890 Old Savannah Road, across the street from where Molly Pond Road intersects today.

The Cotton Exchange Building at 32 Jackson (Eighth) Street, at the northeast corner of Reynolds Street, c. 1900. According to the Welcome Center Brochure, this structure, built in 1886 to house the business activities of brokering cotton to a worldwide market, contained the offices of the brokers and the trading floor for brokers to watch prices of cotton and other commodities. The building was used by brokers until 1964. Restored in 1988–1989, it is currently the Historic Cotton Exchange Welcome Center for Augusta tourism.

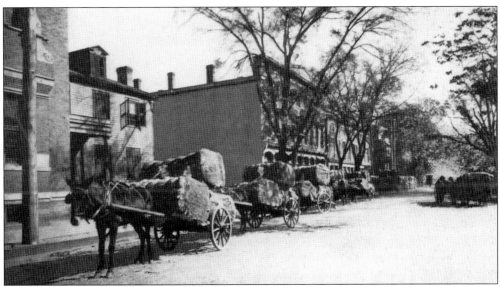

Transportation of cotton by road, Reynolds Street, looking east from Jackson (Eighth) Street, c. 1903. The corner of the Cotton Exchange Building can be seen on the left. The adjacent building at 751 Reynolds Street was the residence of Mr. Osborn M. Stone. The next building contained the offices of the Georgia Chemical Works. Only the Cotton Exchange Building remains today.

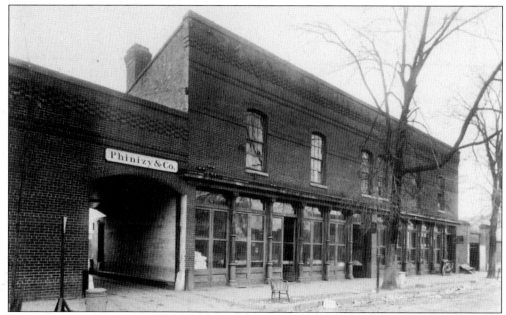

Phinizy and Company, cotton factors, at 5–7 Jackson Street, *c.* 1912. S.M. Whitney Company, cotton factors, occupies the north end at 1–3 Jackson Street. On May 9, 1901, a fire started at the Union Cotton Compress and spread to Phinizy and Company and then to Whitney and Company, where it was stopped. Four thousand bales, valued at $150,000, were destroyed. The *Augusta Chronicle* reported that observers said, "Well, cotton is going down everywhere else, but in Augusta it's going up-in flames!" The site is a parking lot at the entrance to the Riverwalk. (Photograph courtesy of the late F. Phinizy Calhoun Jr., M.D., F.A.C.S.)

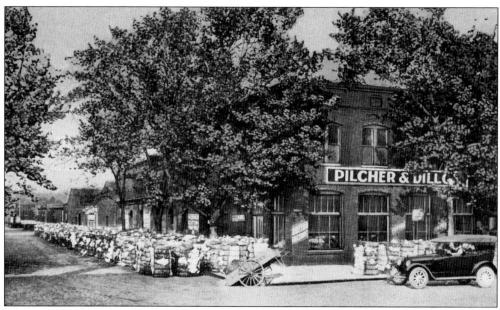

Pilcher and Dillon, cotton factors and commission merchants, at 865 Reynolds Street, on the northeast corner of Campbell Street, *c.* 1920. Joseph S. Pilcher and William P. Dillon Jr. owned the company. Beamie's Restaurant and Oyster Bar occupies the building today.

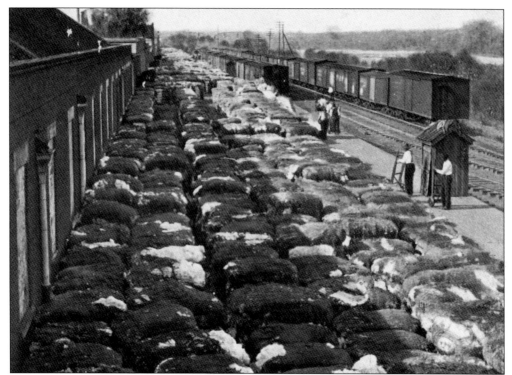

Cotton platform along Bay Street, between Jackson Street and Campbell Street, c. 1903. The S.M. Whitney Company and Union Warehouse and Compress Company cotton sheds are on the left. The Augusta Terminal Railroad tracks and the river can be seen on the right. This site is about where the levee is now.

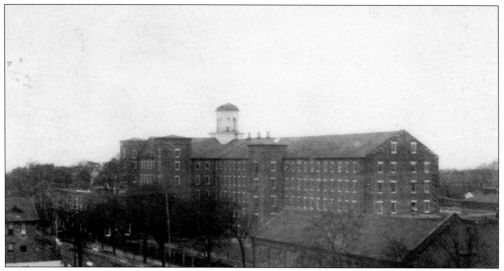

Augusta Factory at 1228 Fenwick Street, between Marbury Street and McKinnie Street, c. 1905. Established in 1847 as the Augusta Manufacturing Company, this was the first mill to utilize the waterpower of the canal system. The company was reorganized in 1859 as the Augusta Factory. The building in the right foreground was used for cotton storage. Over 550 people were employed in 1908. The building was demolished in 1961.

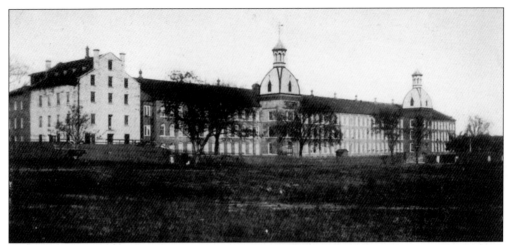

The Enterprise Mill in the 1400 block of Greene Street, *c.* 1905. Organized in 1873, the mill was constructed several years later and enlarged in 1882. The first mill to be constructed on the enlarged canal, it was purposely situated to face north and south to get the benefit of the earliest and latest sunlight, thereby saving on gaslight in the morning and evening. Purchased by the Graniteville Company in 1923, the mill closed in 1983 and is vacant at present.

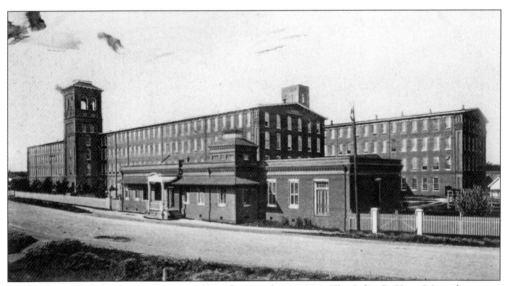

King's Cotton Mills, largest cotton mill in the South, *c.* 1906. The John P. King Manufacturing Co. was located on Goodrich Street at Broad Street at the canal. Organized in 1881, it began operating several years later and employed nine hundred people in 1908. The card message reads: "This is one of the Biggest Mills in this City out of 12 and a good friend to the Army. Hope you have a nice true Xmas and N Year. God Bless you-pray for us. Yours in Christ. W.F.B, Capt. [Salvation Army]." The mill is currently in operation.

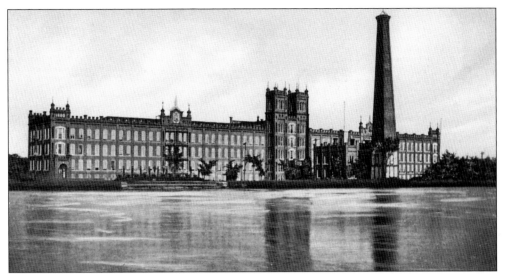

Sibley Manufacturing Company, on Goodrich Street, to the north of the King Mill, c. 1905. The building was completed in 1882 on the site of the old Confederate Powder Works, and the company employed 850 people in 1908. The company merged with the Graniteville Company in 1940 and is currently in operation.

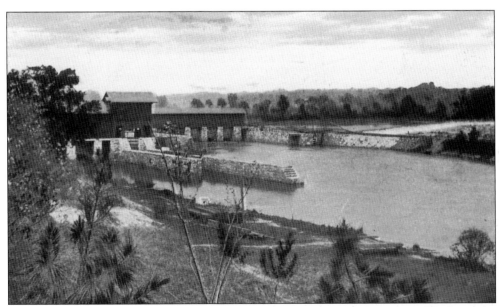

Canal locks, Savannah River, initial port of Augusta's waterpower, c. 1910. Work on the Augusta Canal began in 1845. Many of the workers were Irish immigrants escaping from the potato famine in Ireland. The canal was enlarged from 1872 to 1875. Chinese laborers were brought in to help, and many settled in Augusta after the work was completed. The canal furnished power to the mills and other industries built along its banks. Cotton and farm goods were transported by boat along the canal, which also furnished power for the Confederate Powder Works during the Civil War.

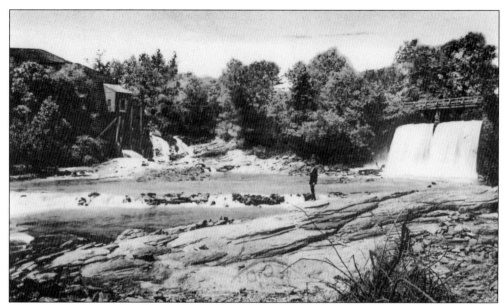

Aqueduct Falls from the canal at Rae's Creek, *c.* 1900. The Warwick Mill is just visible on the left. Located farthest up the canal of all the mills, it was built in 1882. The mill was not in operation in 1904 and subsequently burned. Michael C. White, in his book *Down Rae's Creek*, published in 1994, says a few remnants of the mill can still be seen.

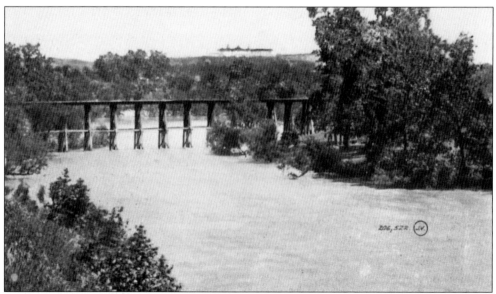

Hawks Gully from Broad Street at Fifteenth Street looking north towards North Augusta, South Carolina, *c.* 1906. The Hampton Terrace Hotel can be seen in the background. The Augusta Terminal Railroad bridge spans the gully. Today, the railroad bridge is gone and the River Watch Parkway bridge spans the gully, just to the north of the old railroad bridge.

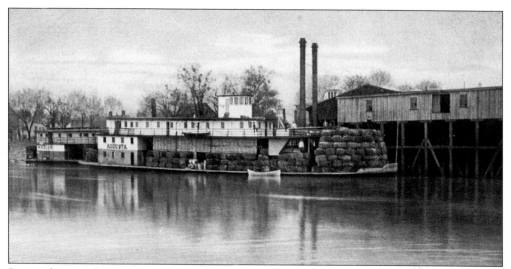

Postcard view of a steamer, c. 1903. The card caption reads: "Steamer loaded with cotton at wharf—Savannah River. The cotton district of Augusta is located along the Savannah River, on which large steamers ply daily between this city and Savannah and other ports. Augusta has ten large cotton mills within a radius of 20 miles, besides many smaller ones. The consumption of these mills is over 100,000 bales of cotton a year." The postcard is c. 1903, but the photograph was probably taken earlier.

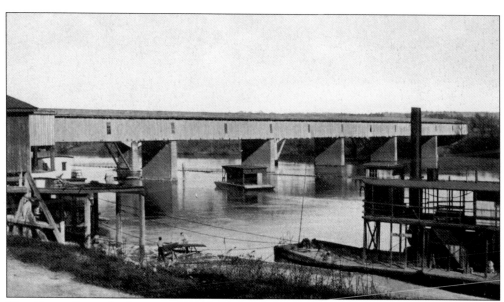

The Centre Street bridge over the Savannah River, c. 1900. It was a 975-foot-long covered wood span. The city wharf is at the left.

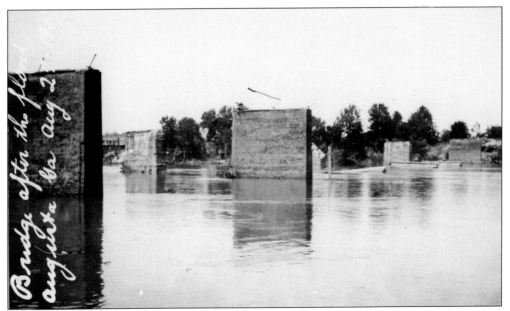

Bridges after the flood, August 27, 1908. At 3:00 on August 26, the old South Carolina Railroad bridge just upstream of the Centre Street bridge gave way and smashed broadside into the Centre Street bridge, carrying it away along with three piers.

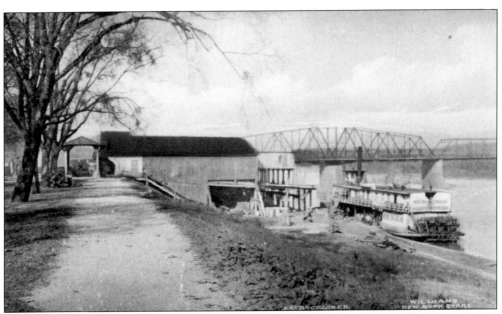

Bay Street, the city wharf, and the Centre Street bridge after the 1908 flood. The City replaced the old wooden bridge with a steel structure. The Centre Street bridge was subsequently replaced with the concrete span that is in use today.

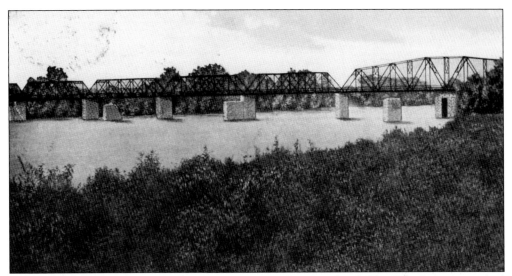

Savannah River and the Centre Street bridge after the 1908 flood. The War Department had been asking the City to install a drawbridge, but they resisted the requests. As it was now necessary to build a new bridge, they decided to include a draw span. A swing draw was constructed on one of the old piers, which was reinforced on each side to allow for the operation of the machinery for the draw span. The large span on the right is the swing draw span, with the pier being just visible next to the trees.

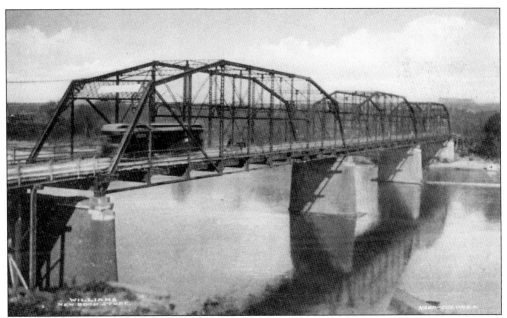

The first North Augusta bridge at McKinnie Street, built in 1891 at a cost of $85,000 by the North Augusta Land Company, c. 1910. James U. Jackson of the North Augusta Land Company envisioned a new town across the river in South Carolina, and the bridge was needed to make development possible. The old bridge was replaced with the current concrete structure in November 1939. The bridge was built at a cost of $200,000 and is named the James U. Jackson Memorial Bridge.

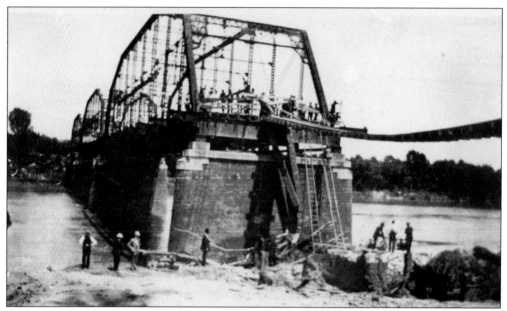

The North Augusta bridge after the flood, August 27, 1908. The south approach of the bridge was destroyed, and the trestle work was washed completely away, leaving the street railway iron suspended in the air. The north approach on the South Carolina side was slightly damaged. Complete repairs were made at a cost of $2,075. The approaches were wood. The steel bridge was not damaged. The card message reads: "This is showing the North Augusta bridge after the flood. The ladders that you see is the way people had to cross over the river until they could fix the bridge back again."

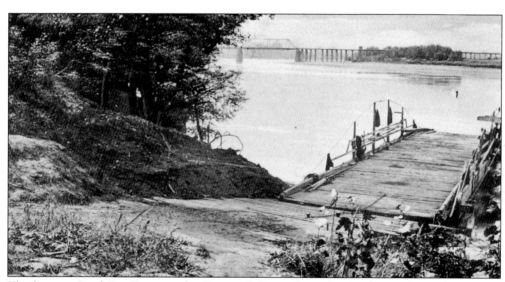

The historic Sand Bar Ferry on the Savannah River from the South Carolina side, looking downstream at the Port Royal Railroad bridge, c. 1900. President Taft's car was carried on this transport on one of his visits to Augusta. It must have been a pretty sturdy ferryboat.

The City Hospital as it appeared after a second addition was completed in 1894. The hospital was located on 533 Walker Street on the northeast corner of Washington Street. The plans were drawn by Dr. William Doughty Jr. Wings were added at each end. The improvements included an operating room and amphitheater, hydraulic elevators, electric bells in the rooms, and a telephone system (Parker and Nichols 1993). A 1913 invoice for patient George Fletcher listed charges of $2.50 for a room for one day and $5.00 for the operating room.

Lamar Hospital at 1225 Gwinnett Street, on the northwest corner of Harrison Street, c. 1910. Dr. William Doughty Jr. was instrumental in obtaining the funds to construct a new hospital for African Americans in 1894. The 75-bed structure was named for Gazeway B. Lamar, who had left funds from his estate "for building of two hospitals for the exclusive care of Negro patients" in Georgia (Parker and Nichols 1993). The hospital burned in 1911, and the Tabernacle Baptist Church was built on the site.

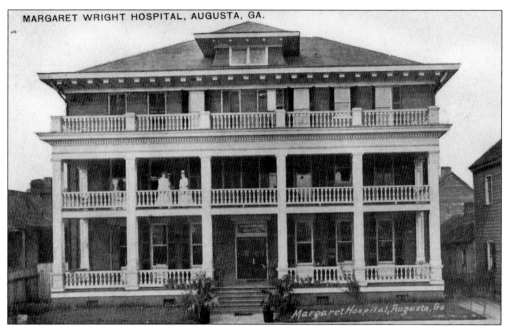

The Margaret Wright Hospital at 1345 Greene Street, *c.* 1915. The hospital was founded about 1908 by Dr. Thomas R. Wright and named for his mother, Margaret Bones Wright. A school of nursing was started in 1909 and trained nurses until the mid-1920s. After Dr. Wright died in the early 1920s, a group of doctors operated the hospital until 1930, when it was closed. The building was used as doctors' offices until the mid-1950s and subsequently demolished. The site is currently occupied by the Salvation Army Thrift Store.

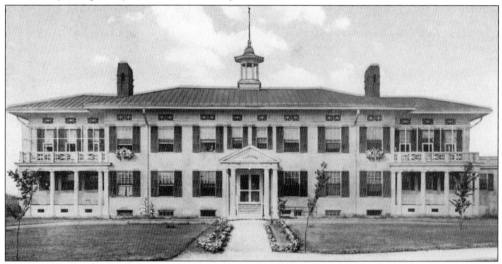

The Wilhenford Children's Hospital at 1436 Harper Street, *c.* 1915. Opened in October 1910, the hospital was built with funds provided by Mrs. Grace Shaw Duff, a frequent Northern visitor to Augusta. She requested that she be allowed to chose the name of the hospital, so she chose a syllable from the names of her father, William; her husband, Henry; and her son, Bradford. After closing in the 1940s, it was reopened as a hospital for tuberculosis patients. The building was demolished in 1959. The Medical College of Georgia's new Childrens Medical Center is currently under construction near the site.

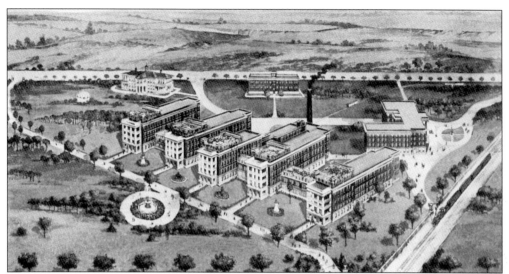

Artist rendering of the proposed University Hospital complex, as designed by G. Lloyd Preacher, on Railroad Avenue at Harper Street, c. 1913. Railroad Avenue was changed to University Place and has subsequently been changed to R.A. Dent Boulevard. A bond referendum was approved by city voters in June 1912 for construction of the hospital, the levee, and the waterworks. A 1923 aerial photograph of the site confirms the builders faithfully followed the proposed plan, with the exception of the outer wings on each end, which were not constructed.

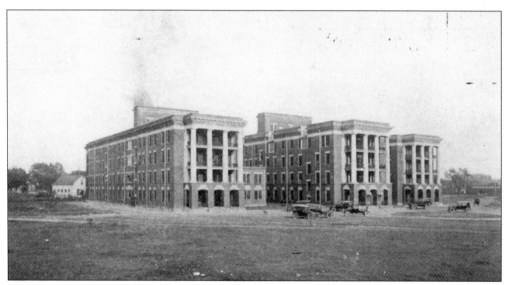

The University Hospital Building, c. 1917. Dedicated on June 1, 1915, after a two-and-one-half-year construction period with separate, but identical wings for black and white patients, the hospital featured 270 beds. The administration building was in the center, the Barrett Wing for whites (named for Mayor Thomas Barrett) was on the left, and the Lamar Wing for blacks (named for Gazeway B. Lamar) was on the right (Parker and Nichols 1993). A new University Hospital opened in 1970, and the old buildings were demolished in 1990.

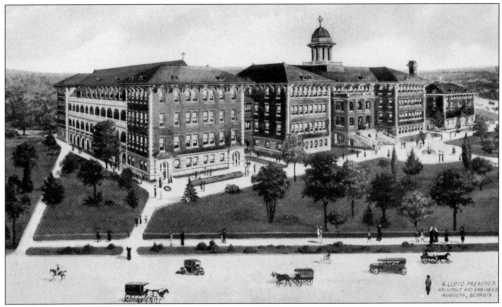

Artist rendering of the proposed Mt. St. Joseph School Building, designed by G. Lloyd Preacher, c. 1913. Located on Wrightsboro Road between what is now Craig Avenue and Whitney Street, the building was constructed as a school in 1913 by the Roman Catholic Sisters of St. Joseph. Economic difficulties forced them to relocate the school to Monte Sano Avenue, c. 1916. The building was sold and converted to a hotel.

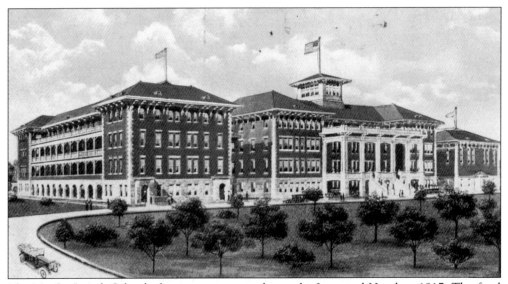

The Mt. St. Joseph School after it was converted into the Lenwood Hotel, c. 1917. The final configuration of the building included a large porch on the front of the center wing and a 20-by-24-foot observation tower, or sun parlor, on the roof. Named in honor of Major-General Leonard Wood, the hotel went bankrupt in 1919 and was then purchased by the Veterans Administration for use as a hospital. Initially known as Lenwood Hospital, the building is now part of the modern, enlarged Veterans Administration Uptown Division.

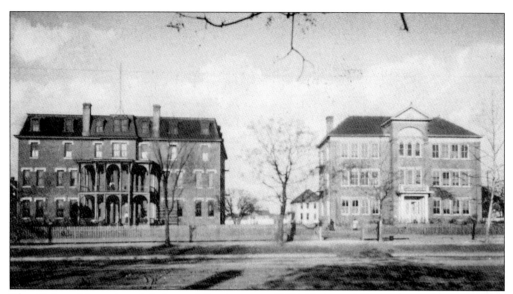

The Haines Normal and Industrial Institute, at 1329 Gwinnett Street (now Laney-Walker Boulevard). The school was founded in 1886 by Miss Lucy Craft Laney, one of the state's most famous African-American personalities. Marshall Hall (1889), on the left, was used for dormitory, dining room, library, and classroom purposes; McGregor Hall (1906), on the right, was the administration building, and they were operated until the late 1940s. The Lucy C. Laney Comprehensive High School was built on the site. The card message reads: "Dr. Robbins, I have not been able to do anything because of my eyes. I shall begin as soon as I can. I trust I can send a lesson in before very long. Truly, Mary C. Jackson. Haines Institute. Sept. 18, 1911."

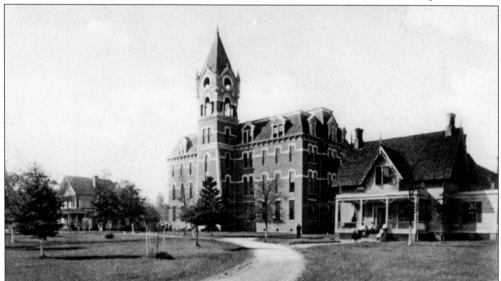

Paine College at 1235 Fifteenth Street. Founded in 1882 as a black college, the original name of Paine Institute, named in honor of Bishop Robert Paine, the senior bishop of the Methodist Episcopal Church, South, was changed to Paine College in 1903. The large brick building with the clock tower was Haygood Hall, built 1897–1899 (Clary 1965). The building was destroyed by fire in 1968. About 1920, the house on the left was the superintendent's home, and the house on the right was the dining hall.

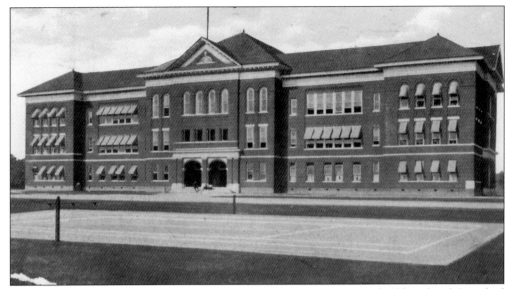

John Milledge School at 1835 Walker Street, *c.* 1915. The front of the building faced Crawford Avenue to the east. The school opened in 1908 with twenty-five rooms. The architect was L.F. Goodrich, and the contractor was T.O. Brown and Son. Named in honor of Georgia governor and Revolutionary War hero John Milledge, the building was replaced with the current school, with the front entrance at 510 Eve Street.

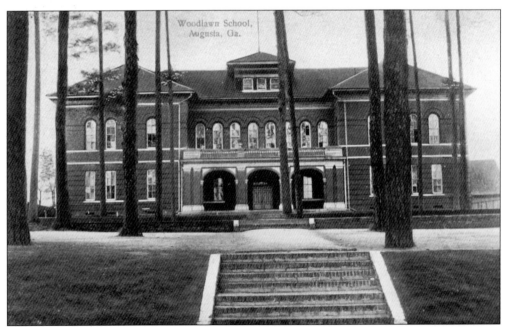

Woodlawn School, at 1101 Fifteenth Street, *c.* 1905. Erected in 1901 at a cost of $30,000, the school had twelve rooms, an assembly hall, library, offices, steam heat, all modern school appliances, and a seating capacity of six hundred pupils. It was named for the neighboring Woodlawn community. The Georgia Veterans Nursing Home is on the site today.

Four
Potpourri

The final chapter will cover a medley of scenes that interested Augustans in the first two decades of this century which did not fit into the categories covered in the first three chapters.

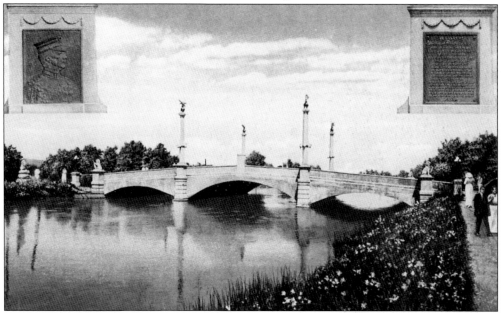

The Archibald Butt Memorial Bridge, *c.* 1915, erected as a memorial to Maj. Butt, who gave his life saving women and children when the *Titanic* sank in April 1912. Work began in the fall of 1912, but construction was delayed because of difficulty experienced in getting a proper foundation and watertight cofferdams. The bridge proper was built by the Concrete Engineering Company of Birmingham with city funds. The memorial work was paid for by the Archibald Butt Memorial Association and put up by the Leland Company of New York. The bridge was dedicated by President William H. Taft on April 15, 1914.

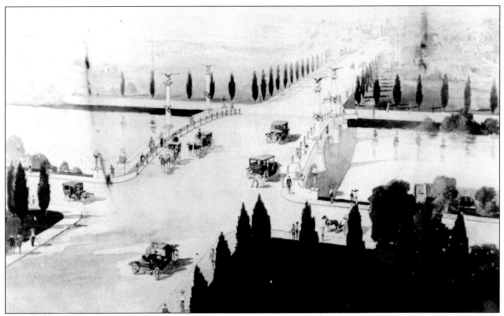

Artist rendering of the Archibald Butt Memorial Bridge showing the proposed memorial work by the Leland Co. of New York. Mrs. John F. Bransford of the Archibald Butt Memorial Association was instrumental in working with the Leland Company in designing the memorial features to be placed on the bridge. The association decided on the bridge as an appropriate honor. The idea was that Maj. Butt himself would prefer something that would render service to others. The canal crossing on Fifteenth Street at Greene Street was chosen as the location.

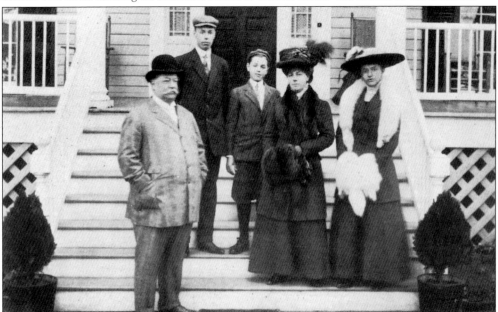

Presidential picture at Terret Cottage, 1908. From left to right, William H. Taft (age 51); son Robert (age 19); son Charles (age 8); wife, Helen Herron (age 47); and daughter, Helen (age 17), are pictured on the steps of Terrett Cottage on Milledge Road in November 1908, when they visited at the invitation of Landon Thomas.

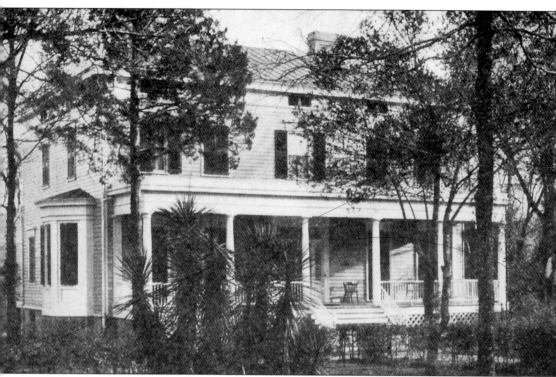

The winter home of President W.H. Taft, Terrett Cottage, 808 Milledge Road on the southeast corner of Cumming Road, *c.* 1910. The building was formerly the home of James Davies, the father of Mrs. Annie Terrett. The house no longer exists.

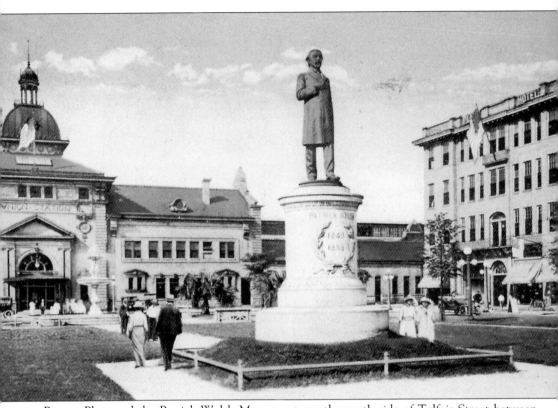

Barrett Plaza and the Patrick Walsh Monument, on the south side of Telfair Street between Jackson Street and Campbell Street, *c.* 1917. The plaza was constructed in 1912 by the City. Old Ford Street and the trolley tracks which ran through the center of the old park were removed, and two streets were laid out on each side and the new plaza. The dirt from the two new streets was used to fill in the old Ford Street roadbed. A large fountain of Italian marble was erected on the Walker Street end. The Patrick Walsh Monument was erected on the Telfair Street end and dedicated in June 1913.

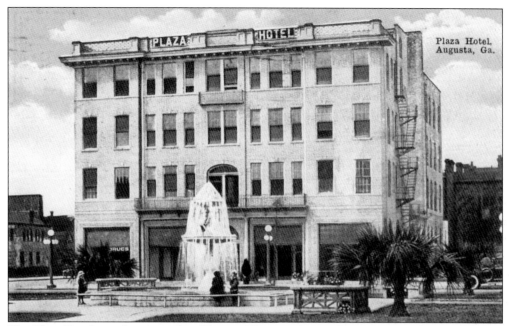

The Plaza Hotel, on the west side of Barrett Plaza on the northwest corner of W. Ford Street and Walker Street, c. 1917. Opened in 1914, Hotel Ada was the name first proposed, but something more original was finally selected. It was popular with travelers using Union Station. Around 1960, it was known as the James Hotel. The building has since been demolished.

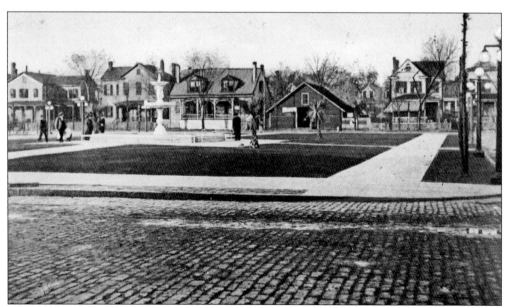

Barrett Plaza, shortly after the work was completed in 1912, but before the Patrick Walsh Monument was dedicated in June 1913. The Barrett Plaza was named for Mayor Thomas Barrett Sr. This view is looking north toward the houses on Telfair Street. The stone pavement in the foreground is Walker Street, in front of Union Station.

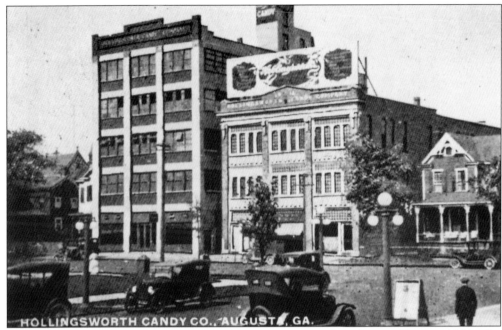

Hollingsworth Candy Company at 827 Telfair Street, across from Barrett Plaza, *c.* 1921. The building on the right was constructed in 1913, and the second building was built in 1920. Founded in 1909 as the Hollingsworth-Tutt Candy Company, the company was known as the Hollingsworth Candy Company when the building on Telfair was constructed. The house on the right side at 821 can be seen in the previous card. The company merged with Nunnally's in 1932 to form the Fine Products Corp. The business is closed, but the buildings have been converted to office space with a common facade.

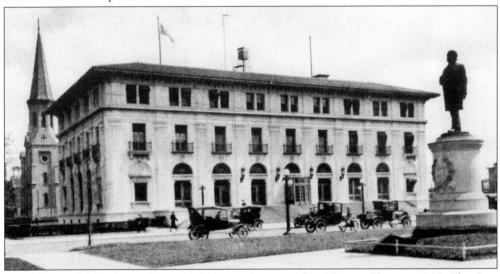

Post office and federal courthouse building on the east side of Barrett Plaza, *c.* 1920. The City gave the federal government the lot at the east end of the old plaza in 1911 in exchange for the old Post Building on the southwest corner of Greene Street and Campbell Street, provided the City purchase the old building, which they did in 1916. The post office relocated in 1973, and the building is now used as the federal courthouse. It has recently been renovated.

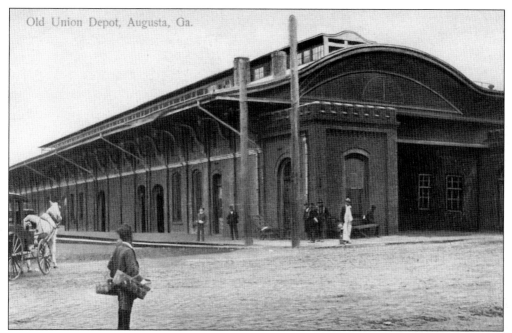

The old Union Depot at the southeast corner of Walker Street and Campbell Street in the late 1800s. The depot was built just after the close of the Civil War, and it was torn down to make way for a new depot in 1902.

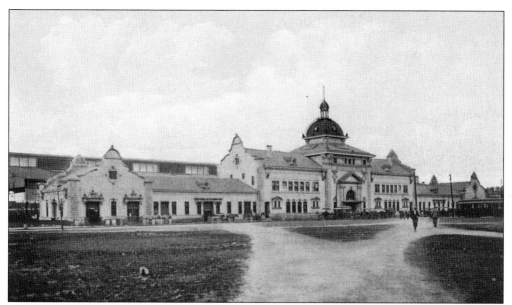

The new Union Depot, located on Walker Street between Jackson Street and Campbell Street, c. 1906. The Union Depot was completed in 1902 at a cost of about $250,000. The old park plaza in front of the station is clearly visible. It was previously bounded by houses and saloons, which were torn down shortly after Union Station opened. Train service ceased in 1968, and the building was demolished in 1972. The current post office and a federal office building occupy the site.

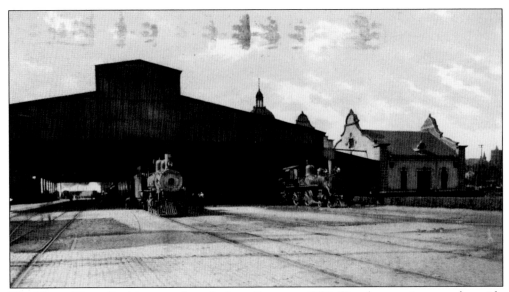

The Union Depot, looking west from Jackson Street, c. 1910. Two locomotives stand outside the metal trainshed which stood behind the depot building. The current post office building occupies this site today.

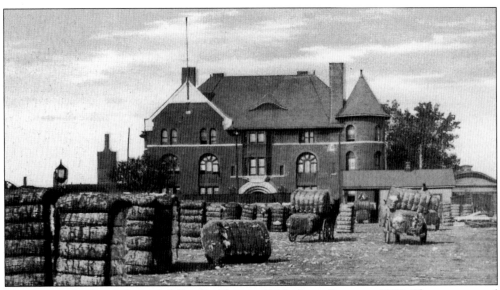

The Georgia Railroad General Office Building at 611 Jackson Street, c. 1900. The western end of the old depot can be seen in the background on the right. A spectacular fire in January 1920 partially destroyed the building. The current post office building is next to the site today.

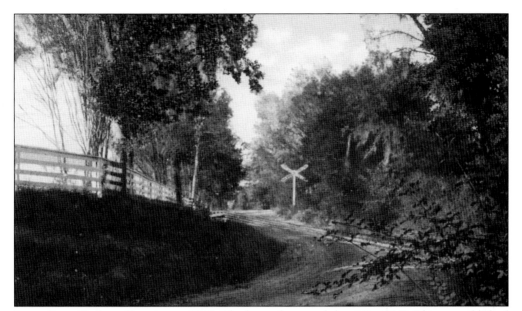

Lovers Lane Railway Crossing, c. 1905. The lovers lane card that Miss W.D. Thomas published added "sure-enough" to the caption. Lovers Lane ran south off Sand Bar Ferry Road and crossed the Port Royal Railroad tracks (Charleston and Western Carolina Railroad), just before Moore's Lagoon. It was a very popular spot for a "drive." Portions still exist, but it is not very romantic today.

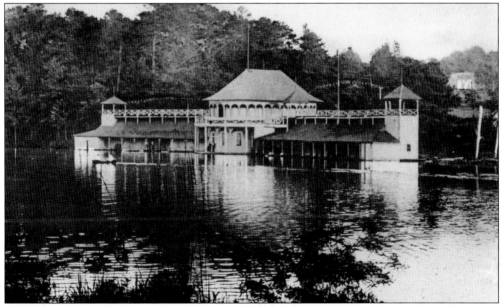

The Lakeside Boat Club on Lake Olmstead in the early 1900s. This club was located on the south side of the lake, near the current Broad Street crossing. In 1873, a lake was created when project engineer Charles A. Olmstead put a dam across Rae's Creek while enlarging the canal. It became known as Lake Olmstead. Lake View Park was developed on the south and east side of the lake. It was a popular recreation area for Augustans in the early 1900s and still is today.

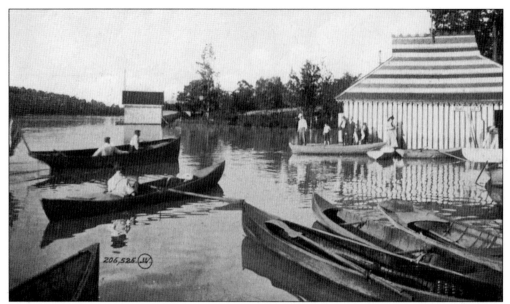

Boathouse at Lake View Park, *c.* 1910. There were private boathouses on the lake in addition to this one where boats could be rented for a trip around the lake. The sign on the side of the boathouse advertises "Boat to Let." (See "Lake Olmstead Rediscovered" by Tom Hunter in *Augusta Magazine*, Summer 1983, p. 22, for a detailed description of the lake and park.)

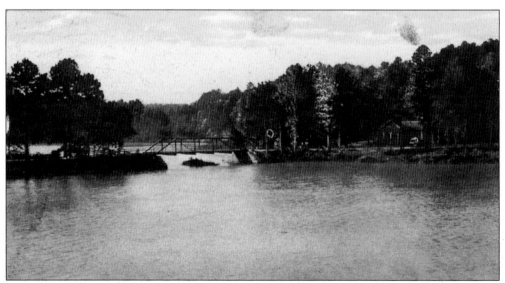

The bridge and Lake View Park, *c.* 1910. The location is the current Lake Shore Loop roadway. The card message reads: "Come on down here and I will take you across this bridge."

May Park looking east, *c.* 1905. May Park was one of the oldest parks in Augusta. It was bounded by Watkins Street on the north, Lincoln Street on the east, Calhoun Street on the south, and Elbert Street on the west. May Park is still in use today, though much altered from what it was in 1905.

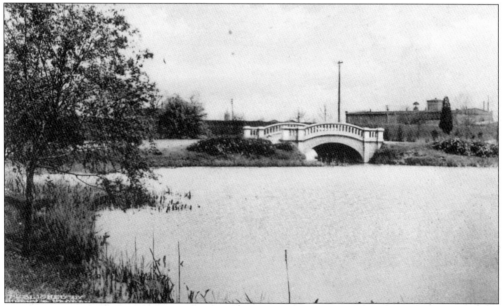

Allen Park, *c.* 1910. The Sutherland Mill is in the background, on the far side of the canal. The old waterworks settling basin was filled in with silt from the canal in the early 1900s to create a park for the families of the nearby factory workers. The City built the bridge to separate the two lakes in the park. The park, named for councilman and Mayor Richard E. "Dick" Allen, was located at the northeast corner of Fifteenth Street and May Avenue (Walton Way), and it was bounded on the north by the first level of the canal. The park has been eliminated by development.

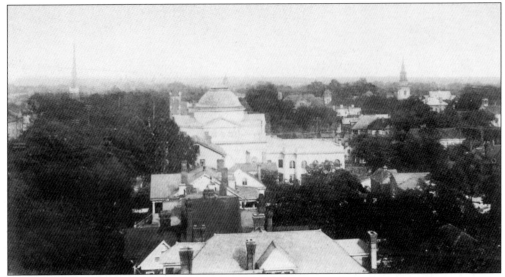

Birds-eye view of the 800 block of Greene Street, looking east from the roof of the post office building tower on the southwest corner of Greene Street and Campbell Street, c. 1905. The First Baptist Church is in the center foreground. The First Christian Church steeple is on the left, and the steeple of the Church of the Most Holy Trinity (St. Patrick's) is on the right.

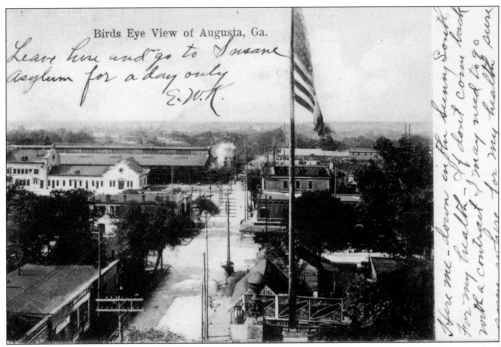

Birds-eye view of Campbell Street, looking south towards Union Station from the roof of the post office building tower on the southwest corner of Greene Street and Campbell Street, c. 1905. The card message reads: "Here me—down in the sunny South for my health—If I don't come back with a contract I may need to go some where for my health [for] sure—Leave here and go to Insane Asylum for a day only."

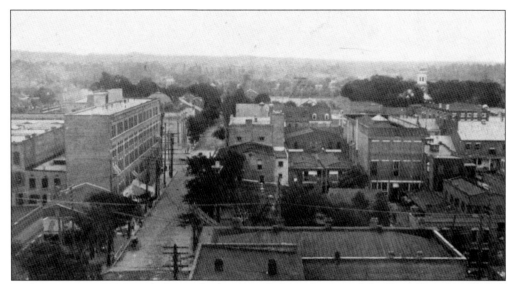

Bird's-eye view of McIntosh Street, looking north from the rear of the First Christian Church on the northeast corner of Greene Street and McIntosh Street, c. 1905. The five-story building on the left at Broad Street and McIntosh Street is the new Leonard Building. The dome of the Georgia Railroad Bank building can be seen directly across Broad Street from the Leonard Building. The steeple in the right background is St. Paul's Church.

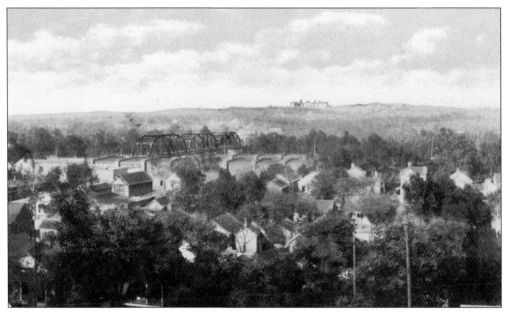

Bird's-eye view looking north from the tower of the new Fire Department Headquarters building at 1253 Broad Street, c. 1911. The North Augusta bridge and the Hampton Terrace Hotel can be seen in the background. The card message, from February 15, 1912, reads: "Hampton Terrace is the beautiful hotel in North Augusta. You see it on the hill at a distance. Carson Cottage is opposite. See how far above the Savannah River (indicated by the bridge). Superb location and climate, but a spell of cold weather was here."

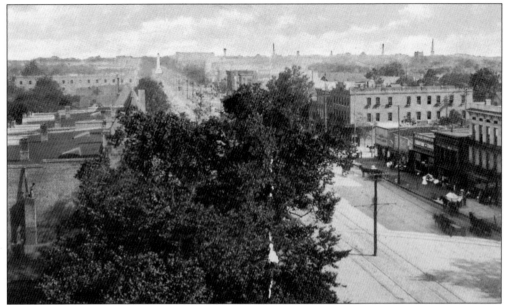

Bird's-eye view of Broad Street, looking east from the tower of the new Fire Department Headquarters building at 1253 Broad Street, *c.* 1911. The three-story building at the right edge of the view is the Daitch Building at 1216–1218 Broad Street. The two-story building to its left at 1212 Broad Street was replaced by the Steinberg Building in 1912. The next three-story building to the east is the Brislan Building, at 1162–1168 Broad Street on the northwest corner of Marbury Street. All these buildings are still standing today.

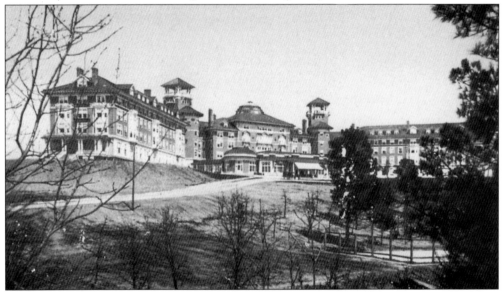

The five-story Hampton Terrace Hotel, between Georgia Avenue and Carolina Avenue, just south of Martintown Road in North Augusta, South Carolina, *c.* 1905. Built by the North Augusta Hotel Company, which was headed by James U. Jackson, it opened in December 1903. It was advertised as "The Most Magnificent Winter Resort in the World." A short circuit in the wiring in the walls of the third floor caused a fire that totally destroyed the hotel on December 31, 1916 (North Augusta Historical Society 1980).

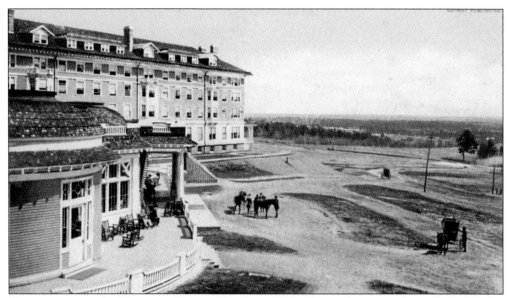

The entrance to the Hampton Terrace Hotel, *c.* 1905. The card message from a Broad Street card reads: "The Genesta, Augusta, GA. Dec. 31, 1916. Dear Sister, Our hotel burned last night. We are all right. Leave here 7:30 tomorrow morning for Boston by way of 'Savannah Line' and will get there Thursday night or Friday morning. Don't worry for we are all right. Will be glad to get home." They escaped when the Hampton Terrace burned early morning on December 31, 1916.

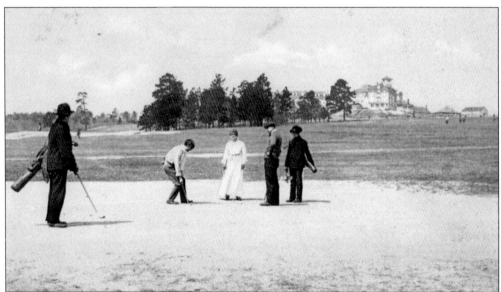

Golf course, Hampton Terrace Hotel, *c.* 1905. The hotel offered many amenities for the pleasure of its guests. It featured an eighteen-hole golf course with the first tee and last hole within 100 feet of the hotel. The card message, from January 25, 1909, reads: "We like this place ever so much. Great sports. Horseback riding, tennis, golf, dancing. Friday it was up to 78. Yesterday 75. I shook hands with Taft Wednesday at a banquet given here. Quite an honor." (A banquet for president-elect Taft was held January 20, 1909.)

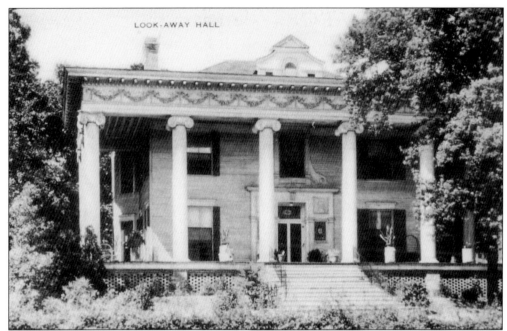

Look-Away Hall at 103 Forest Avenue, in the forks between Georgia Avenue and Carolina Avenue, in North Augusta, South Carolina, c. 1920. One of the most recognizable landmarks in North Augusta, Look-Away Hall was built by Walter Jackson about 1895. Later, it was purchased and occupied by Dr. and Mrs. Henry G. Mealing for many years.

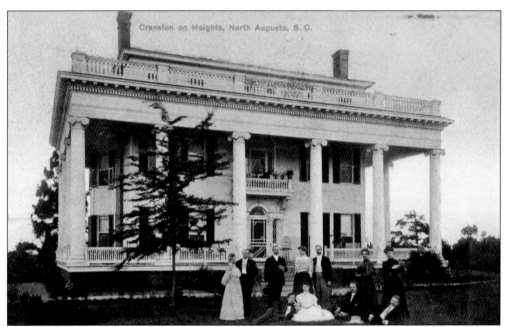

Cranston on Heights at 1002 Carolina Avenue in North Augusta, South Carolina, c. 1906. Built in 1900 by John M. Cranston, it was torn down in 1972, when the Holy Trinity Lutheran Church was built on the site. The card message, from May 6, 1908, reads: "We are at the King Daughters convention held in Augusta. Having a fine time. Will leave Friday for home."

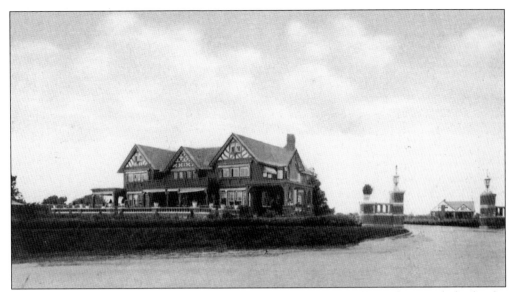

Palmetto Lodge at 750 (now 1208) Georgia Avenue, c. 1918. Built as a hunting lodge by the owners of the Hampton Terrace Hotel, it was purchased by John W. Herbert of New York before 1908. He named the home "Palmetto Lodge." One of the later occupants of the home was the author Edison Marshall. It has been known as Seven Gables in recent times and has been used as a tourist home and motel.

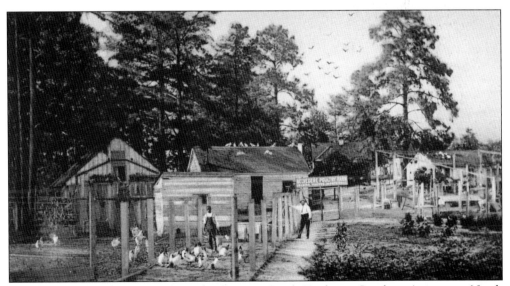

Belvedere Poultry Farm and the Belvedere Pet Stock Yards on Carolina Avenue in North Augusta, South Carolina, c. 1903. Leonard F. Verdery was the proprietor. The sign advertises chickens, rabbits, and pigeons for sale. I don't think they meant for sale as house pets. Pigeon pie was popular in those days.

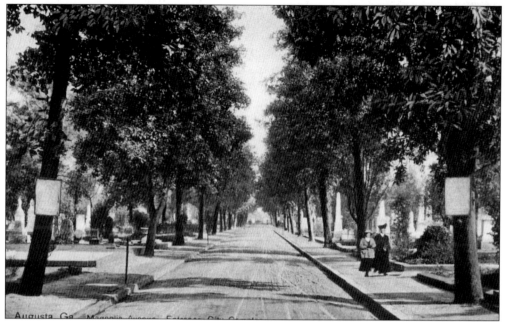

Magnolia Avenue entrance, City Cemetery, c. 1915. Now known as Fourth Street and Magnolia Cemetery, the cemetery became a city-operated cemetery in 1817, but it is thought a private graveyard was once located on the site, as the oldest tombstone is dated 1800. Burials took place at St. Paul's or family burial plots before then. The number of burials has been variously reported between 35,000 and 45,000. Lots were sold out many years ago, but families who own the lots and have vacant space continue to use their lots. The cemetery is located at 702 Lincoln Street, bounded on the north by Watkins Street, the east by Houston Street, the south by Gwinnett Street (Laney-Walker Boulevard), and on the west by Lincoln Street.

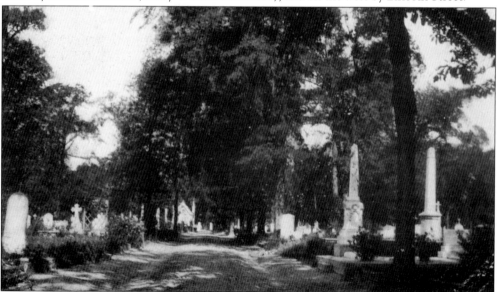

City Cemetery (now known as Magnolia Cemetery), on Second Street looking west toward the chapel that was located at Second Street and the west wall, c. 1905. The chapel was demolished many years ago.

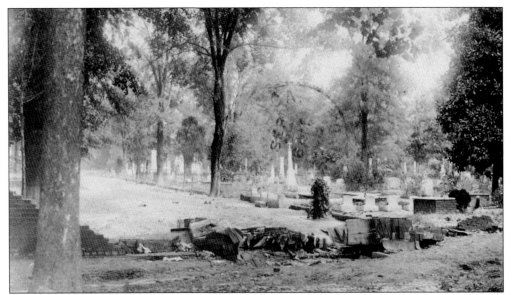

Flood damage to the west wall in City Cemetery (now known as Magnolia Cemetery) at First Street caused by the August 1908 flood. This view is looking east from Lincoln Street. The repairs are still discernible in the wall today.

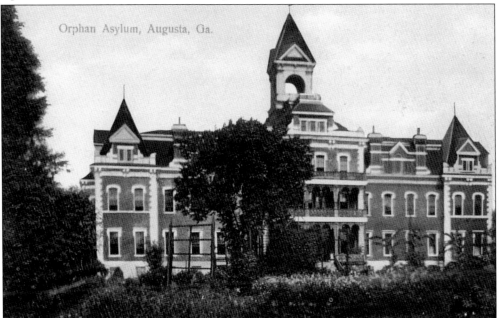

The Augusta Orphan Asylum on Railroad Avenue (now R.A. Dent Boulevard) and Harper Street, c. 1906. D.B. Woodruff of Macon, Georgia, was the architect, and William H. Goodrich of Augusta, the builder. It opened in August 1873. The interior burned August 11, 1889, and it was rebuilt with minor changes, reopening on December 24, 1890. In 1912, the orphans moved to a new facility at Gracewood, Georgia, and the Medical College of Georgia moved into the building in January 1913. The building was torn down in 1960. (Russell Moores 1995.) More related information is available in the May 1995, July 1995, March 1996, July 1996, and October 1996 issues of *Southern Echoes*.

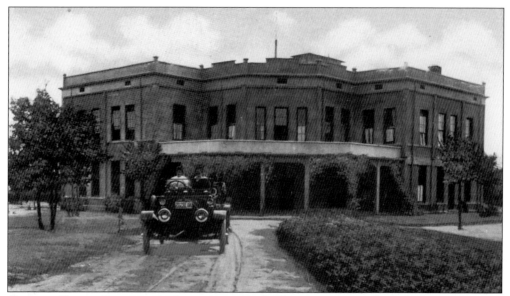

Orphans Home, Gracewood, Georgia, c. 1915. The Augusta Orphan Asylum moved to Gracewood in 1912. This was one of the buildings on the campus. The name was officially changed to the Tuttle-Newton Home in 1919.

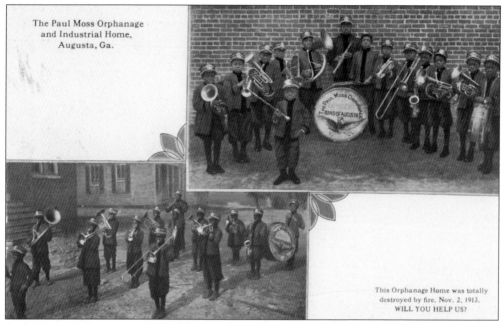

The Paul Moss Orphanage and Industrial Home, Augusta, Ga.

This Orphanage Home was totally destroyed by fire, Nov. 2, 1913. WILL YOU HELP US?

Paul Moss Orphange, c. 1913. This card caption reads: "The Paul Moss Orphanage and Industrial Home. This Orphanage Home was totally destroyed by fire, Nov. 2, 1913. **WILL YOU HELP US?**" An article in the *Augusta Chronicle*, on November 3, 1913, said: "Fire Destroyed Negro Orphanage. The entire 2 story building of the Paul Moss Orphanage outside the city was burned yesterday. In that section known as South Nellieville and is outside the city limits. Fireman absolutely helpless as no water was available. No fatalities among colored children inmates. Call received by telephone." The orphanage, at Milledgeville Road and Fifteenth Street, was operated by Paul D. Moss, president and manager.

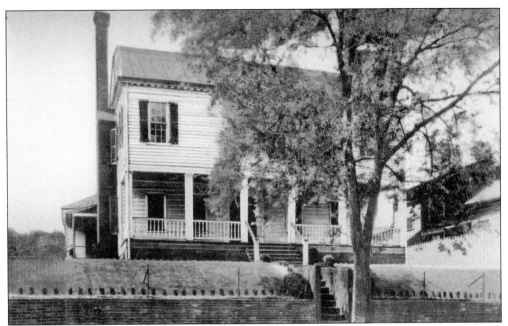

The historic "White House," c. 1920. For many years, the "White House," or Mackay House, was mistakenly identified as the place where thirteen Colonial soldiers were hanged and the location of a Revolutionary War battle site. In 1975, it was determined that the structure was built about 1797 by tobacco merchant Ezekiel Harris. Located at 1822 Broad Street, it has been restored to its original appearance and is now operated as a house museum.

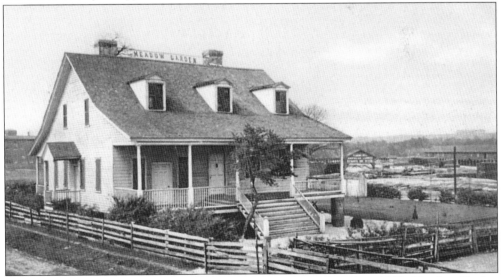

Meadow Garden at 1320 Nelson Street (now Independence Drive), c. 1903. Meadow Garden was the home of George Walton from about 1793 to 1804. Walton was one of the Georgia signers of the Declaration of Independence, a delegate to the Continental Congress, and governor of Georgia. The home is a museum owned and operated by the Georgia State Society NSDAR. The buildings of the Perkins Manufacturing Company can be seen in the right background on Walker Street at McKinnie Street. The Perkins site is currently occupied by American Concrete, Inc.

Phinizy's Old Mill, at New Savannah Road where Rocky Creek crosses just north of Lumpkin Road intersection, *c.* 1920. This message, sent from Phinizy & Phinizy, cotton factors, on December 30, 1922, reads: "On the reverse side of this card is a picture of Phinizy's Old Mill; It was here that Eli Whitney operated his first cotton gin. Please accept the card with our best wishes for a prosperous and happy new year. Phinizy & Phinizy."

The Old Powder Mill Chimney, Monument to the Confederate Dead, 1717 Goodrich Street, in front of the Sibley Mill, c. 1910. The 168-foot high chimney is all that remains of the Confederate Powder Works complex built on this site during the Civil War by Col. George Washington Rains. In a speech to the Augusta City Council in 1872, Rains asked that the chimney be preserved as a monument to the dead, and it was saved when the City demolished the Powder Works complex. The Sibley Mill office building is behind the chimney, and the superintendent's home can be seen in the distance. The home no longer exists.

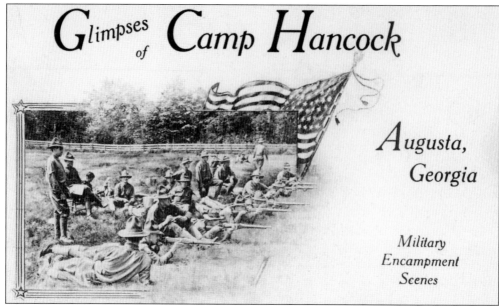

Glimpses of Camp Hancock

Augusta, Georgia

Military Encampment Scenes

Camp Hancock, c. 1918. When the United States entered WW I, there were no adequate facilities available for training the almost four million men that were to serve in the U.S. Army. Many camps had to be built for the training program. Local officials and congressional politicians promoted Augusta as a potential site, and subsequently, Augusta was awarded a National Guard cantonment designated Camp Hancock in honor of Major-General Winfield Scott Hancock, U.S.A. The National Guard of Pennsylvania was designated the 28th Division and moved to Camp Hancock for training in August and September of 1917.

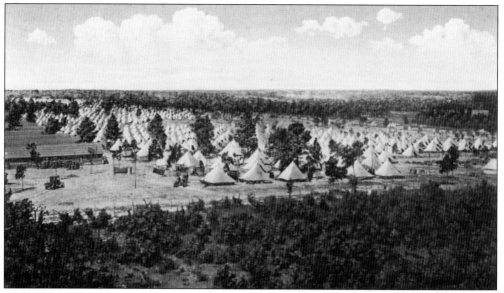

Tent City, Camp Hancock, c. 1918. This is the site of the 56th Infantry Brigade from a view looking west along what is now Pine Needle Road and Park Avenue from the waterworks reservoir embankment at Buena Vista Road. The card message reads: "Expect to leave here, Camp Hancock, Ga., within 48 hours for some post to ship for France. Have you missed me, or forgotten. I am going to be commissioned Sergeant. Hope you are all well."

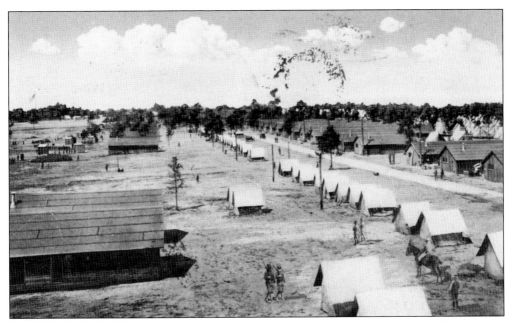

Pennsylvania Avenue in Camp Hancock, c. 1918. This street ran from what is now Buena Vista Road west to the Augusta University Sports Complex, running parallel to Wrightsboro Road, about on line with Pine Needle Road. A short portion is still visible in a wooded area on the Forest Hills Golf Course complex. The card message reads: "Dear Bro: A trip down here thru this country you would enjoy. I am a regular soldier now, and not a bit home sick."

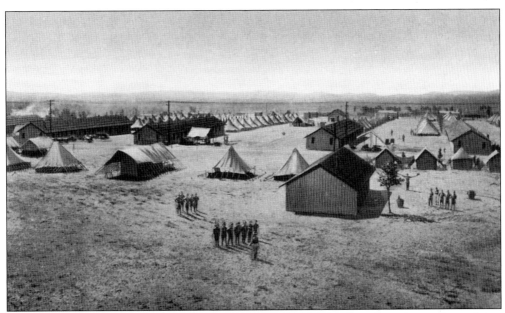

Artillery section, Camp Hancock, c. 1918. The 53rd Field Artillery Brigade was located just south of the current Uptown Division of the Veterans Administration, overlooking the Highland Park area. The card message reads: "We are in a place where winter is scarcely known. How would you like to be here? Am having a fine time. Lots of cotton and cactus here."

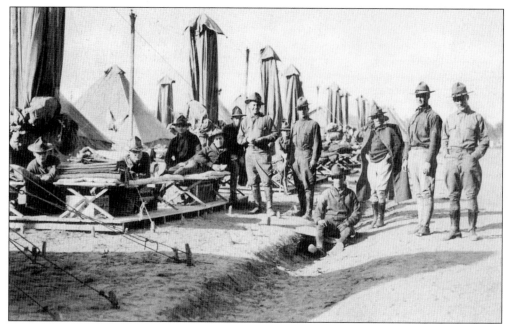

Tent inspection, Camp Hancock, *c.* 1918. Lessons learned about hygiene and sanitation during the Spanish-American War, twenty years earlier, were applied in WW I, making airing of tents a regular drill for the camp soldiers. The card message reads: "Hello grandpa, I am well hope you the same. I like it here but not like home. Write soon." This card was published by Murphy Stationery Company.

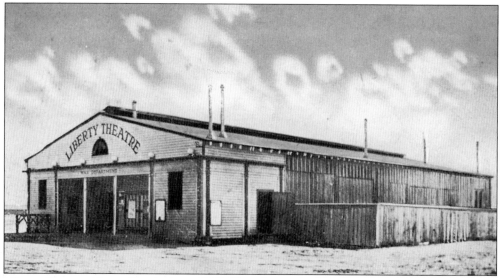

Liberty Theater, Camp Hancock, *c.* 1918. This theater building was located on Wrightsboro Road, just east of where Pine Needle Road intersects it. It was completed in May 1918 at a cost of $6,250. The card message reads: "It has been raining about all the a.m. I am well and hope all you people are too. We have not much to do to-day & Sun. We played before the Major Gen. yesterday in a large review. Several thousand men in parade with 4 bands. We played at Meadow Garden in Augusta at 6 o'clock to about 7:30 at the home of John Walden [sic] one of the signers of the Declaration of Independence."

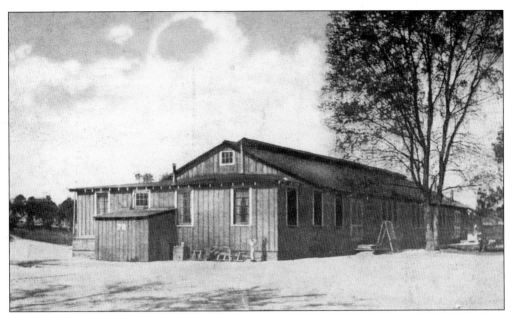

YMCA Hut No. 78, Camp Hancock, c. 1918. There were about a half-dozen YMCA facilities scattered throughout the campsite. Hut No. 78 was located on Wrightsboro Road, just west of what is now Pine Needle Road. The card message reads: "This afternoon many thousands of men (between 15 and 20, I guess) were formed in a big machine gun spread eagle and a picture taken from a high tower for future preservation. It took several hours to finish."

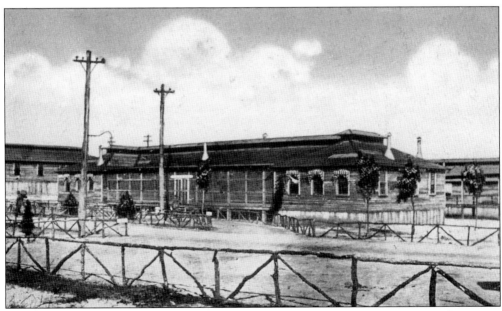

Administration Building, Base Hospital, Camp Hancock, c. 1918. The base hospital at Camp Hancock was located in the area a few hundred yards south of Wrightsboro Road, between what is now Whitney Street and Johns Road. St. Joseph's Hospital is adjacent to the site. The card message reads: "We have a great camp here and are having quite a good time along with the hard work."

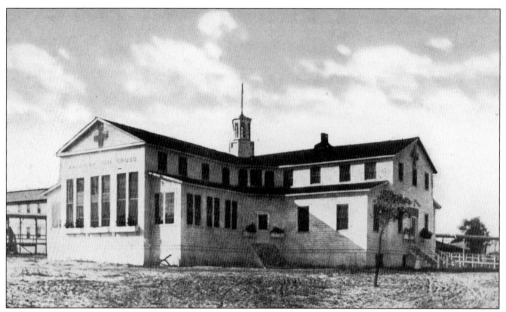

Red Cross Building at Base Hospital, Camp Hancock, *c.* 1918. This building became a part of the Lenwood Hospital complex. It does not exist today. The card message reads: "This life is the best thing that could ever happened. When I come home I will be straight as a stick, strong as a horse & healthier than I ever was. I am making use of every thing that come along."

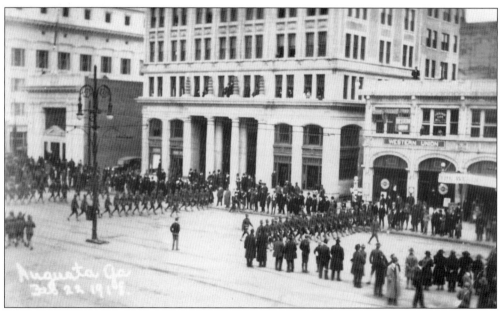

The 28th Division from Camp Hancock parading down the 700 block of Broad Street for Augusta citizens on February 22, 1918, prior to departing for France in late April. The card message reads: "We were changed into a machine gun company Tuesday and think I will like it better than infantry for we do not have the rifles any more."

Soldiers Club at 629 Broad Street, c. 1918. This is the same building temporarily used by the *Augusta Herald* just after the 1916 fire. The building still stands. The card message reads: "How am you all dese days? It am quite hot down here, but gittin long fine."

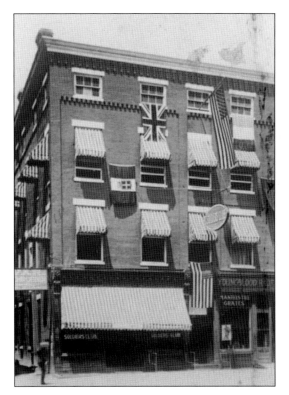

Machine Gun Training Center insignia. After the 28th Division departed Camp Hancock, a machine gun training center was established. On December 10, 1918, photographers Mole and Thomas from Chicago assembled 22,500 officers and men and 600 machine guns into a gigantic human insignia. On the ground, it measured 880 feet across and 640 feet from top to bottom. The view is north at Wrightsboro Road and Pine Needle Road. The building barely visible in the background just at the top of the right wing is YMCA Hut No. 78. Photographs of the insignia could be purchased for 75¢ each.

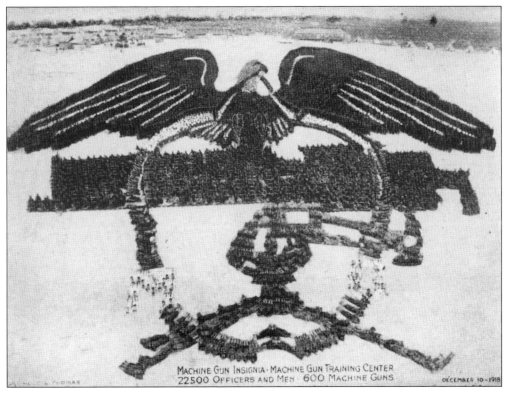

MACHINE GUN INSIGNIA · MACHINE GUN TRAINING CENTER
22500 OFFICERS AND MEN · 600 MACHINE GUNS DECEMBER 10-1918

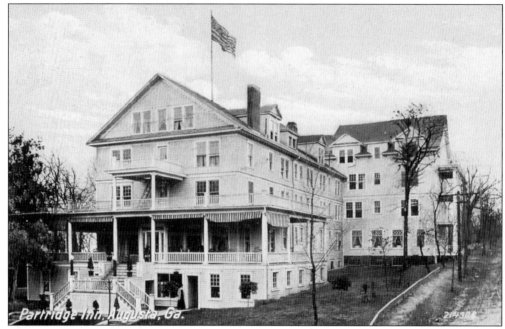

Partridge Inn, *c.* 1910. Morris W. Partridge began expanding the old Meigs home (in the rear) at Walton Way and Meigs Street around the turn of the century to accommodate the increasing tourist trade in Augusta and Summerville. This view is looking west up Walton Way from the intersection of Telfair Street (now Hickman Road).

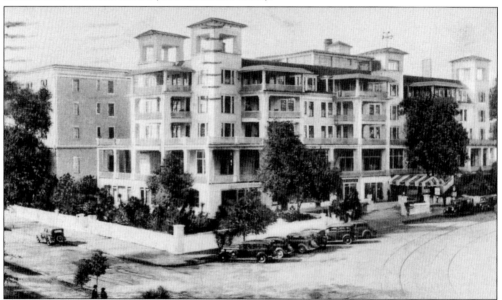

The Partridge Inn in the 1920s, at the height of its expansion. The handwritten card message reads: "Dear Mrs. Martin, Do hope you will favor us with your valued patronage should you decide to come to the south land this winter. Hoping to have the pleasure of making reservations for you. Partridge Inn. M.W. Partridge, Prop." Mr. and Mrs. Partridge were known for the personal attention to their guests. After a period of decline, the building was restored and is in operation again under the original name.

118

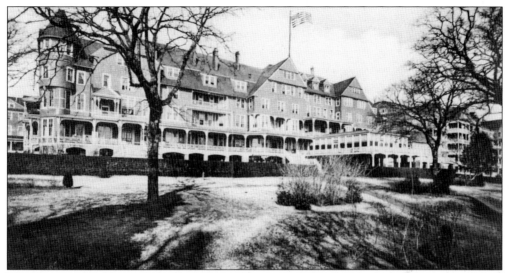

The Bon Air Hotel, c. 1909. The first hotel on the Hill, it opened in 1889 to attract the Northern tourist trade to Summerville (and Augusta). The season was from December to May. It featured 105 rooms, steam heat, an elevator, a grand parlor for balls, reading rooms, billiard rooms, parlors for ladies and gentleman, an elegant dining room, and electric lights. Its popularity assured, the hotel expanded rapidly to almost 270 rooms. The hotel was destroyed in a fire on February 3, 1921.

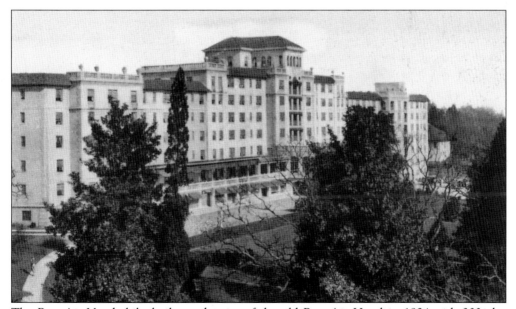

The Bon Air Vanderbilt, built on the site of the old Bon Air Hotel in 1924 with 300-plus rooms, c. 1925. It flourished for several decades as a popular tourist retreat. After a long period of decline, the Bon Air closed as a hotel in the mid-1960s. It has been remodeled several times and is currently operating as the Bon Air Apartments.

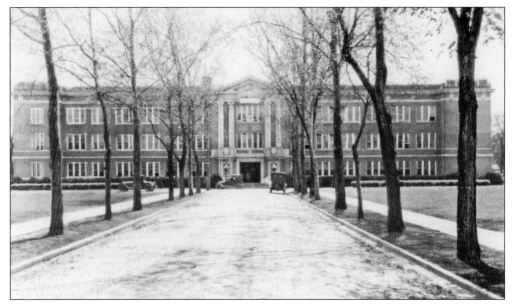

Tubman High School at 1740 Walton Way, c. 1920. This school was built on the site of the old Schuetzenplatz in Summerville after the school on Reynolds Street burned in the 1916 fire. G. Lloyd Preacher was the architect. Opened in February 1918, the building had twenty-two classrooms, two study rooms, three laboratories, sewing and cooking rooms, an auditorium, gymnasium rooms, shower baths, principal's and teachers' offices, and art and commercial departments. T. Harry Garrett was the principal. The school is operated today as Tubman Middle School.

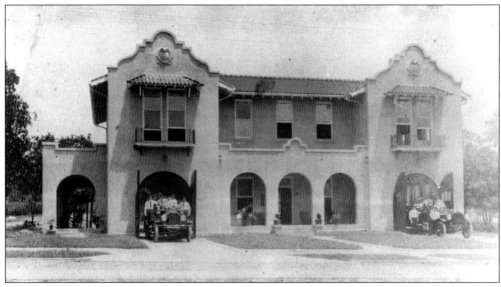

Fire Station No. 7 at 2163 Central Avenue on the northeast corner at Troupe Street, c. 1915. Completed in 1914 by T.O. Brown and Son, the station had sleeping quarters, a billiard room, a reading room, bathrooms, and a large locker room. The building was put into service on May 1, 1915, with eleven men. On the left is a Seagrave Motor Triple Pump (750 gallons), built in 1915. On the right is a Seagrave Motor Combination Chemical and Hook and Ladder, built in 1914. The station is still in operation.

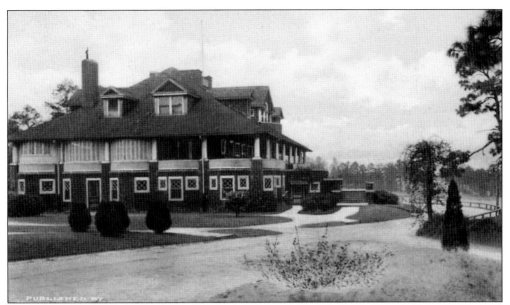

Country Club at 655 Milledge Road, *c.* 1914. Built in 1902, it possessed large reception rooms; dining rooms; a billiard room; a cafe where meals could be obtained a la carte; locker rooms, equipped with shower baths, for ladies and gentlemen; and all other conveniences. It was associated with the Bon Air and the Partridge Inn, whose guests could use the facilities. This building was destroyed by fire in 1961. New facilities were constructed, and the private club continues in operation today.

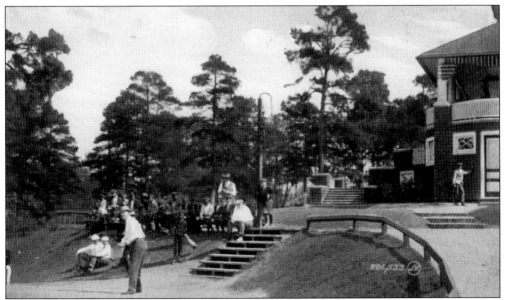

Tee No. 1, Country Club Golf Links, *c.* 1914. Two golf courses were available for play, the Lake Course and the Hill Course. Each course started and finished at the clubhouse. A card message dated April 8, 1909, when only the Lake Course was open, reads: "This looks pretty good doesn't it. You ought to be down here and get in some practice for summer. The best course I ever saw, about."

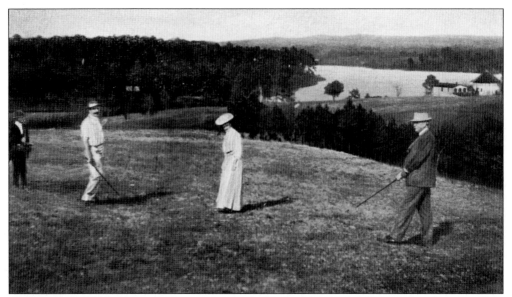

Golf Links, c. 1910. The Lake Course overlooked Lake Olmstead and the Lakeside Boat Club. In 1926, the front nine was 3,131 yards for par 36, while the back nine was 2,943 yards for par 35. The site is now occupied by the Country Club Hills subdivision.

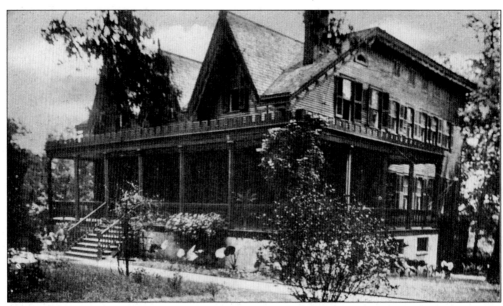

Three Oaks at 826 Hickman Road, c. 1915. Anna Platt Heard Smith opened her home for boarders in the late 1800s, after the death of her first husband. The card message reads: "This shows you the house where we eat when not dining out. The house is not pretty but is filled with many interesting articles of furniture & curios—many valuable antiques and the eats are dandy. No style but an abundance of good, well cooked food—almost too many kinds at dinner. The cook is a young colored woman about Nell's size but not over 22 years old. She's a wonder." An apartment building occupies the site today.

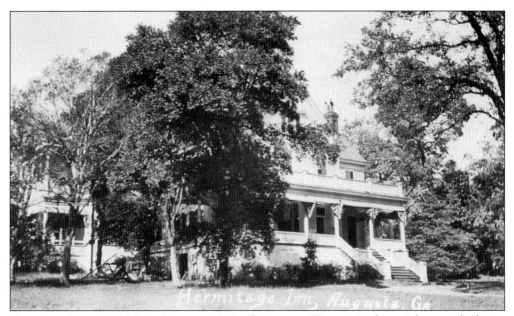

Hermitage Inn at 927 Meigs Street, *c.* 1920. The inn was Tracy I. Hickman's home, which was opened up to boarders about 1917 with Miss Ellen Hickman as the manager. It operates today as the Hickman Park Apartments.

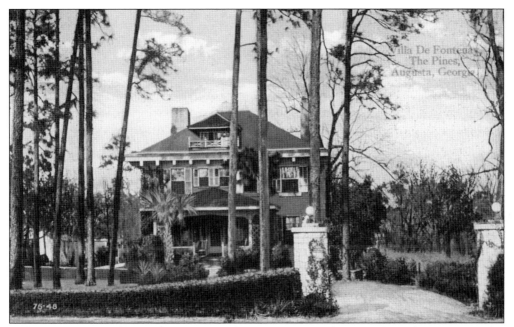

Villa De Fontenay, the Pines, at 2425 Walton Way, across the street from the Augusta State University campus, *c.* 1920. G. Lloyd Preacher designed and built a complex of three houses at 2425, 2427, and 2429 Walton Way under the name "The Pines" in the 1910s. Preacher lived in this house about 1920. This house and the one at 2427 are still standing. The house at 2429 on the northeast corner of Fleming Avenue burned a few years ago and has been replaced with a brick structure.

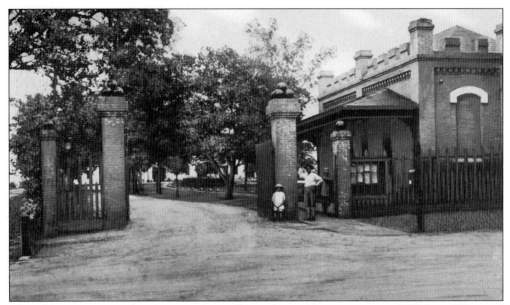

The old entrance to the Augusta Arsenal on the southwest corner of Walton Way and Katherine Street. In his *Summerville Recollections*, Mr. Frank E. Clark Jr. identified the "small" sentry on duty as Buck Lanier, age 5. The entrance posts are gone, but the building survives. The old Arsenal property is now the campus of Augusta State University.

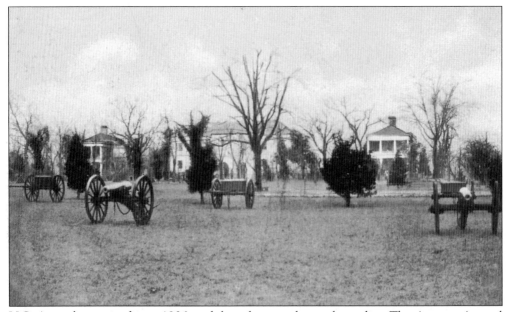

U.S. Arsenal, seen in this *c.* 1906 card, but photograph may be earlier. The Augusta Arsenal was established in 1819 on the Savannah River, near the Sibley Mill site. It was moved to the Hill in 1829 because of unhealthy conditions at the river site. This scene was featured in Ken Burns's Civil War documentary. The arsenal was closed in 1955, and the property is now the site of Augusta State University. The three buildings shown are, from left to right: the Benet House, Payne Hall, and Rains Hall.

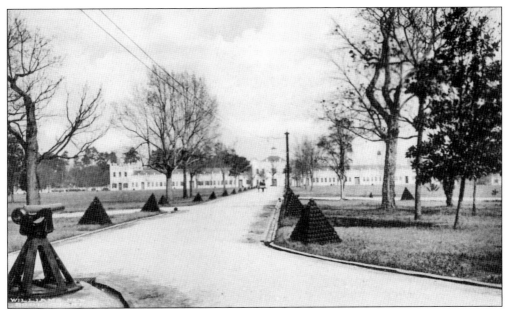

U.S. Arsenal, c. 1910. This view is looking east from the front of what is now Payne Hall toward the shop building. The Augusta State University library building would be on the left now. The shop building was built in 1861 by the Confederate government after they seized the arsenal from U.S. forces. The building was torn down after the school took over the property in the mid-1950s.

Mary Warren Home for women at 2109 Central Avenue, c. 1915. The home was moved from downtown to the Hill in 1915. G. Lloyd Preacher was the architect for this new structure. The card message, dated April 6, 1915, reads: "We have moved in and we are all so happy over it—the Consecration Service will be tomorrow afternoon. Wish so much you could be with us." The home has closed, and the building is currently vacant.

Bibliography

Augusta. Official Publication Augusta Chamber of Commerce.

Augusta Chamber of Commerce. *1908 Yearbook*. Augusta: *Augusta Chronicle*, Job Printing Department, 1908.

Augusta Chronicle

Augusta Chronicle. One Hundred and Fiftieth Anniversary, May 12, 1935.

———. 175th Anniversary, Six Special Editions, March 6, 1960 to August 28, 1960.

———. Bicentennial Edition, May 12, 1985 to October 6, 1985.

Augusta City Directories.

Augusta Herald

Augusta Herald, 50th Anniversary, 1890–1940, September 22, 1940.

Augusta Magazine.

Augusta, Georgia April 1884. New York: Sanborn Map & Publishing Company, 1884.

Augusta, Georgia 1890. New York: Sanborn-Perris Map Company, 1890.

Augusta, Georgia 1904. New York: Sanborn Map Company, 1904.

Bell, Earl L. and Kenneth C. Crabbe. *The Augusta Chronicle, Indomitable Voice of Dixie, 1785–1960*. Athens: University of Georgia Press, 1960.

Callahan, Helen. *Augusta: A Pictorial History*. Virginia Beach: Donning Company/Publishers, 1980.

Cashin, Edward J. *The Quest: A History of Public Education in Richmond County, Georgia*. Augusta, Georgia, 1985.

———. *The Story of Augusta*. Augusta: Richmond County Board of Education, 1980.

———. *The Story of Sacred Heart*. Augusta: Sacred Heart Cultural Center and Streeter Printing and Graphics, Inc., 1987.

Clary, George E. Jr. "The Founding of Paine College." Ph.D. diss., University of Georgia, 1965.

Cumming, Joseph B. *A History of Georgia Railroad and Banking Company and Its Corporate Affiliates, 1833–1958*. Privately printed, 1958.

Fleming, Berry. *199 Years of Augusta's Library, A Chronology*. Athens: University of Georgia Press, 1949.

Flythe, Starkey. "The Lamar Building." *Augusta Magazine*, November-December 1988, 24.

Fogleman, Marguerite Flint. *Historical Markers and Monuments of Richmond County, Georgia*. Augusta: Richmond County Historical Society, 1986.

German, Richard Henry Lee. "The Queen City of the Savannah: Augusta, Georgia, During the Urban Progressive Era, 1890–1917." Ph.D. diss., University of Florida, 1971.

Hanson, Robert H. *History of the Georgia Railroad*. Johnson City, TN: Overmountain Press, 1996.

Insurance Maps of Augusta, Georgia. New York: Sanborn Map Company, 1954.

Kirby, Bill, ed. *The Place We Call Home, A Collection of Articles About Local History from the Augusta Chronicle*. Augusta: *Augusta Chronicle*, William S. Morris, Publisher, 1997.

Jones, Jr., LL.D., Charles C. and Salem Dutcher. *Memorial History of Augusta, Georgia*. Syracuse, NY: D. Mason & Co., Publishers, 1890; reprint, Spartanburg, SC: Reprint Company, 1966.

Miller, George and Dorothy Miller. *Picture Postcards in the United States 1893–1918*. New York: Clarkson N. Potter, Inc./Publisher, distributed by Crown Publishers, Inc., 1976.

Moores, Russell. "Tuttle-Newton Orphanage History." *Southern Echoes*, May 1995, 1.

North Augusta Historical Society. *History of North Augusta, South Carolina*. Marceline, MO: Walsworth Publishing Co., 1980.

Parker, Barry and Bob Nichols. *For the People, the Commitment Continues: University Hospital History*. Augusta, 1993.

Richmond County History. Augusta: Richmond County Historical Society.

Rowland, A. Ray and Helen Callahan. *Yesterday's Augusta*. Seemann's Historic Cities Series No. 27. Miami, Florida: E.A. Seemann Publishing, Inc., 1976.

Shivers, Louise. "Citizens and Southern: A True Southern Citizen." *Augusta Magazine*, Winter 1979, 17.

Spalding, Phinizy. *The History of the Medical College of Georgia*. Augusta and London: University of Georgia Press, 1987.

Year Book of the City Council of Augusta, Georgia, 1909 and 1910.